EXTRAORDINARY SKETCHBOOKS

JANE STOBART

BLOOMSBURY
LONDON • NEW DELHI • NEW YORK • SYDNEY

First published in 2011 by
A&C Black Publishers, an imprint of
Bloomsbury Publishing PLC
50 Bedford Square
London WC1B 3DP
www.bloomsbury.com

Text copyright © Jane Stobart 2011
Images copyright © the individual artists

CIP Catalogue records for this book are
available from the British Library and the US
Library of Congress

Book design by Bradbury & Williams
Cover design by Sutchinda Thompson
Publisher: Susan James

ISBN 978-1-4081-3442-9

This book is produced using paper that
is made from wood grown in managed,
sustainable forests. It is natural, renewable
and recyclable. The logging and
manufacturing processes conform to the
environmental regulations of the country
of origin.

Printed and bound in China.

Picture credits
1: Corinna Button
2: William Kentridge
3: Linda Wu

Thirteen Ideas for Sculpture 1937
Page from *Sketchbook of Sculpture Ideas*
HMF 1364
chalk, pencil, watercolour
260 x 203mm
signature: pencil l.l. Moore/37
photo: The Henry Moore Foundation archive

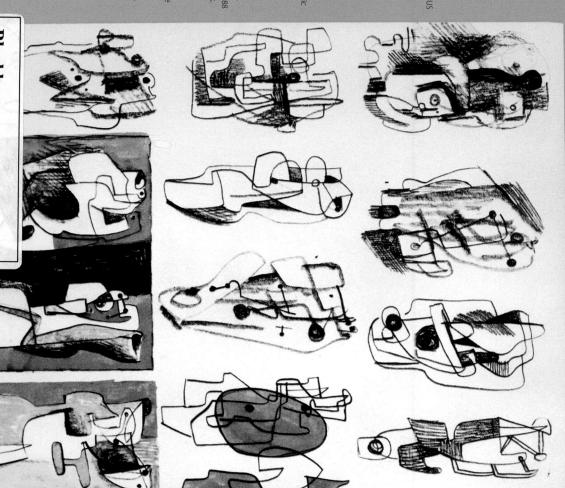

Contents

Acknowledgements

I AM IMMENSELY GRATEFUL TO THE 31 ARTISTS AND
designers who have so generously given of their time, their patience
and most importantly for opening up their glorious sketchbooks.
I would also like to thank the following people for their support and
assistance in the making of this book.

Peter Courtley
Anne Daniels
Judy Groves
The Henry Moore Foundation
Judy Holland
Penny Hughes-Stanton
Alan Hunter
Arthur Lockwood
Anne McIlleron
Jen Miller
Wendy Mooney
Judith Park
Emily Peters
Stacey Searle
Mustafa Sidki
Martin Smith
Jennie Stanbridge
Faye Wren

Introduction

IT HAS BEEN SUCH A JOY TO PRODUCE THIS BOOK AND

to sample so many wonderful sketchbooks from a wide variety of creative people. I asked everyone if their sketchbooks were a private concern between themselves and their drawings, doodles, thoughts and ideas and nearly everyone said that they were. However this book is about to change all that and expose a few pages from each contributor! Brought together in one book, the diversity and quality is amazing. It reveals many approaches to image-making in addition to demonstrating the great variety of purposes that sketchbooks can serve. This book makes a strong case for the benefits of keeping a sketchbook whether you are a student, a professional artist or designer, or simply somebody who likes to draw, make patterns, or play around with colour and shape.

I have taught at almost every level of education and have always made a point of recommending the use of sketchbooks for collecting research and developing ideas. I feel strongly that the best sketchbooks have a theme linking the contents together. All of the examples in this book come from sketchbooks with a particular purpose, such as recording travels in India, drawing in jazz clubs, hatching ideas for illustrating a novel, etc. A few years ago

when I discovered that my cat was pregnant I started a sketchbook to document her expanding belly and continued until suckling kittens appeared, and beyond. Like many people, I keep a range of sketchbooks for the different themes that I am working on. All of my ideas are realised through the process of printmaking but everything that I create starts life in a sketchbook. Henry Moore numbered his pages and Sheila Graber now dates all of her sketchbook entries. The very personal accounts in this book explain something of the individual relationships that the creators have with their sketchbooks.

I have no doubt that the work in this book will inspire the reader just as much as it has inspired me. If you don't already keep a sketchbook, then perhaps there will be ideas here that will lead you to do so. If you are already a sketchbook fan, then I believe there will be suggestions that will increase ideas for new ways of documenting research, developing ideas, or for methods of image-making that may not have occurred to you before.

Feast your eyes.

JANE STOBART, 2011

David **Meldrum**

GRAPHIC DESIGNER AND ARTIST DAVID MELDRUM
was touched and inspired when he discovered sketchbooks by his
grandfather and great-grandfather and felt these to be an amazing
insight into them as individuals. He likes the thought that his own
books will be looked at by his family for generations to come. As a
keen collector of early advertising signage and ephemera, David
enjoys documenting such things in his books, 'as a way of keeping a
personal, historical reference and record.' He is currently working in
a large heavy-paper hardback pad for a special project, 'but I usually
prefer a Moleskine concertina sketchbooks that are pocket-sized, or
square, ring-bound books for drawing on location.'

David's sketchbooks document life around him, both inside and
outside his home. His most recent book centres on a self-set project
where he is attempting to document everything that he eats and
drinks over a period of a year. The images focus on packaging,
typography, food and produce. He works on his 'food book for
approximately one to two hours a day. This unique project has
caught the imagination of various food chains as well as some
newspapers, both in the UK and USA. Two or three times a week he
works in other sketchbooks. 'I also document people in my journals,
usually when I'm travelling or sitting in bars or pubs. When people
realise you are drawing them, they can be uncomfortable but I have
never had any problems, most people are intrigued. Once when I
was in France a man came over and drew alongside me.' ▷

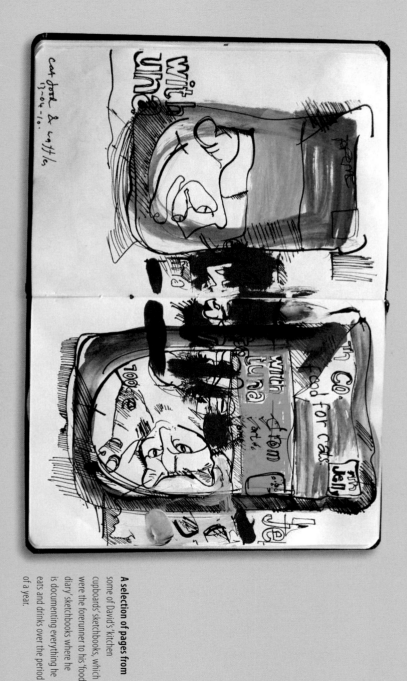

cat food & craft/s
17-04-10.

A selection of pages from
some of David's 'kitchen
cupboard' sketchbooks, which
were the forerunner to his 'food
diary' sketchbooks where he
is documenting everything he
eats and drinks over the period
of a year.

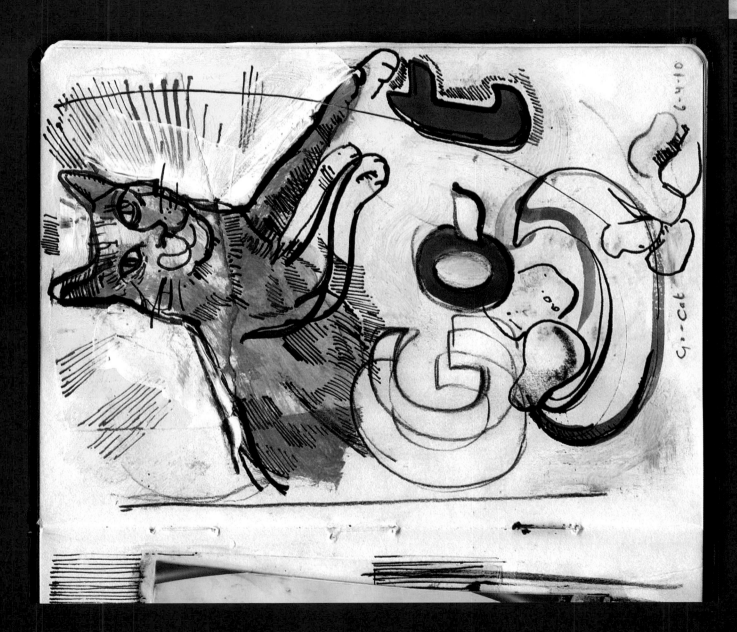

Gr-Cat 6-4-10

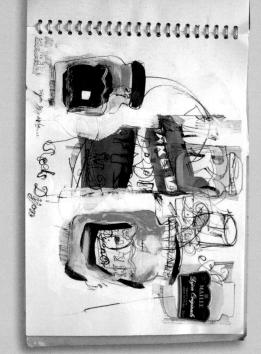

His approach to image making is mixed media. 'In the food book I am using acrylic, gouache, collage, pen, ink and watercolour. My favorite is a Pilot V pen, a disposable fountain pen, but I also use a dip pen and ink (one of my grandfathers). In my reportage journals I use a range of fine-liners.' David considers his sketchbook as something completely detached from any of the other creative activities he's involved in. 'It is purely a visual diary that I connect

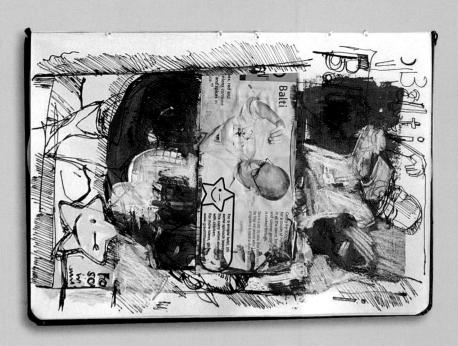

into, I never develop any sketchbook work further but view it as an entity in its own right.' His dialogue with his books is private when he is in the process of creating them, but he is very happy to share the work with others when a book is complete.

Looking back through his large collection of sketchbooks from over the years, David experiences a strong reminder of time, place and atmosphere. He feels that these visual records are a great deal more evocative than photographs could ever be. 'I could not imagine ever not keeping a sketchbook.'

Felicity **House**

THE BEAUTIFUL SKETCHBOOKS OF ARTIST FELICITY HOUSE are packed with drawings and paintings made directly from her subjects. She is inspired by travel and new places but responds equally to domestic scenes, such as complex interiors, figures and portraits. Felicity likes to work in books not larger than A4. She always uses top-quality paper for both drawing and painting. 'The heavy paper in a Moleskine drawing book is great, also superb Two Rivers Paper bound in a handmade book, and Saunders Waterford are favourites, in both NOT and HP papers. I like spine bound sketchbooks so I can work across the spread – always hardback – much more sturdy when I'm on the move.' Felicity is never without a sketchbook and might use it several times in a week, but when travelling abroad she will use it almost constantly.

'When away on a trip it's really a visual diary, a means to record fast, especially when I might not have time for a painting. Some pages will include a number of small images – drawn or painted "snapshots" to get a flavour of the place. These will be carried out in just ten minutes of fast looking and recording whilst exploring new territory; I will use a viewfinder to help me with these. In the end these sketchbooks are lovely things to look at and they evoke a sense of the place – the heat, smells, vibrancy and buzz of a place. Other sketchbooks will be used as source material from which to make paintings.' When Felicity was teaching full time, she kept a 15-minute-a-day sketchbook and would recommend this to her students as an achievable way of improving their drawing. ▷

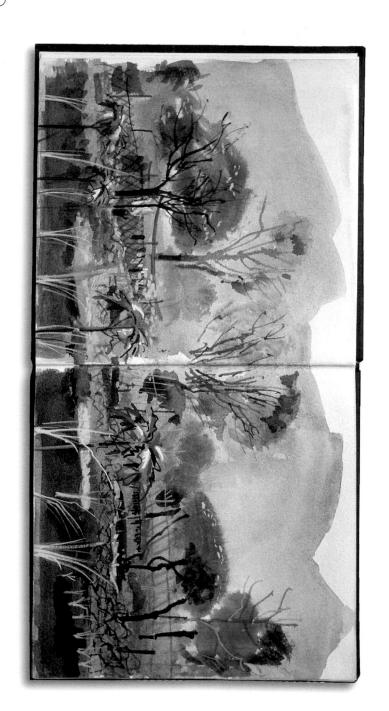

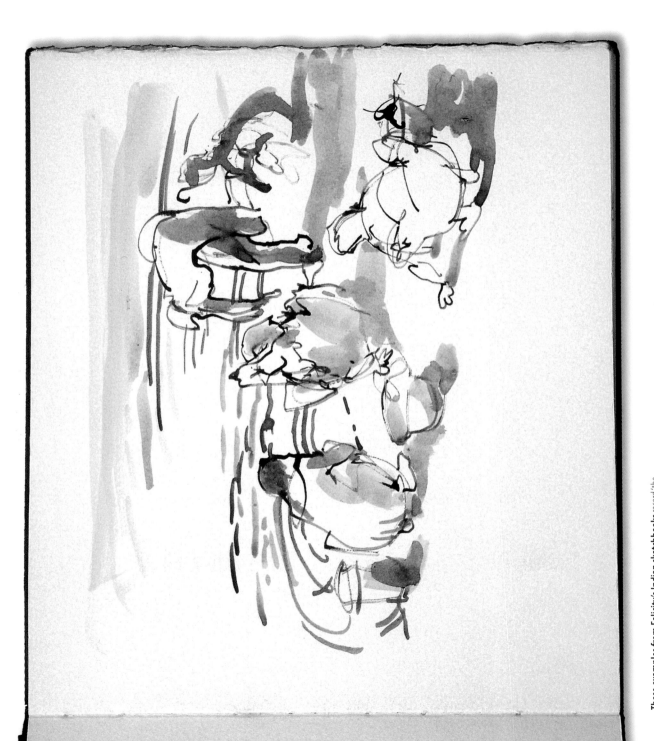

These examples from Felicity's Indian sketchbooks record 'the beautiful or intriguing or odd'. She is never without a sketchbook, inspired by travel and new places but equally by domestic scenes, such as complex interiors, figures and portraits.

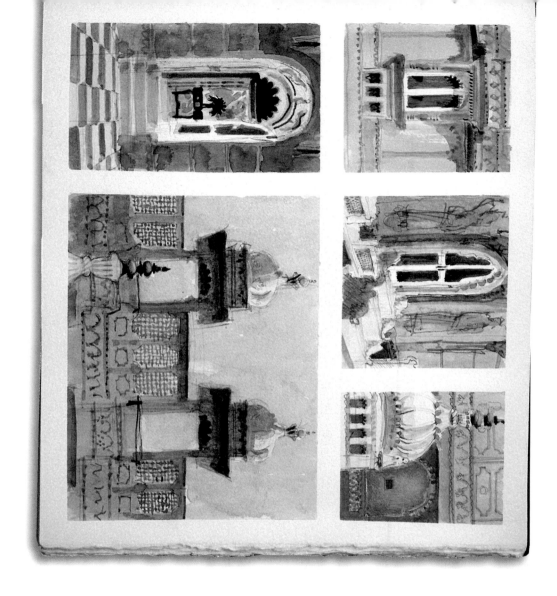

Felicity works in a sketchbook 'for the sheer pleasure of recording what I've seen. The beautiful or intriguing or odd; its about what I've noticed, what my eye has rested on – pattern, shape, colour, composition – one visually selects and draws what attracts you to the scene / image / object.' Her most recent travel book was made on a trip to Italy. She also has a small book kept for the life drawing class that she teaches, to remember poses. 'I keep a tiny book to draw in when I'm at the ballet where I don't take my eyes off the stage; it records the shapes and movements. Another one is kept for landscape drawings, often done from the car.'

The sketchbooks that have influenced and inspired Felicity include that of her illustration tutor Tony Kerins, artist Tom Coates, Neil Meacher RI and watercolourist Robert Wade. The refined paintings and drawings of both Eric Ravilious and John Ward have also provided inspiration.

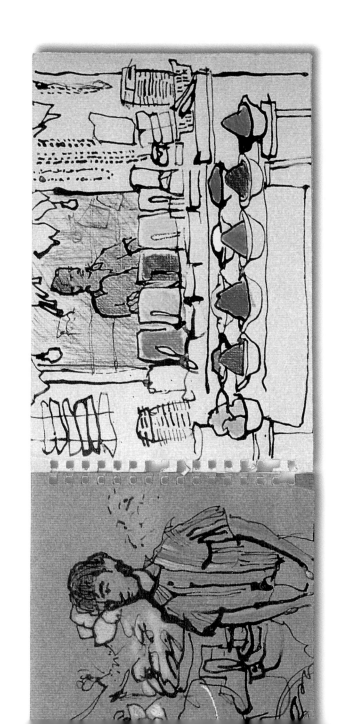

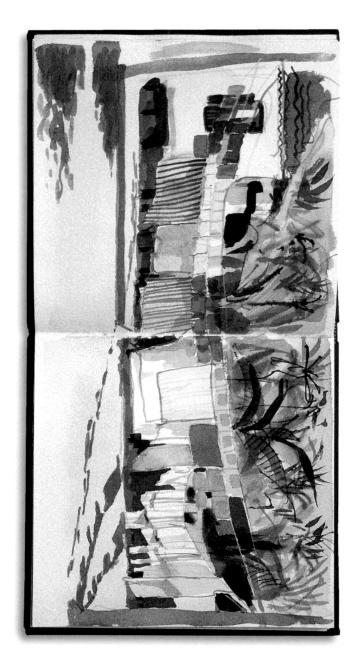

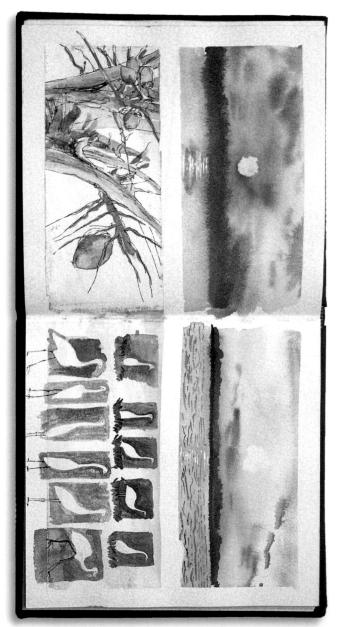

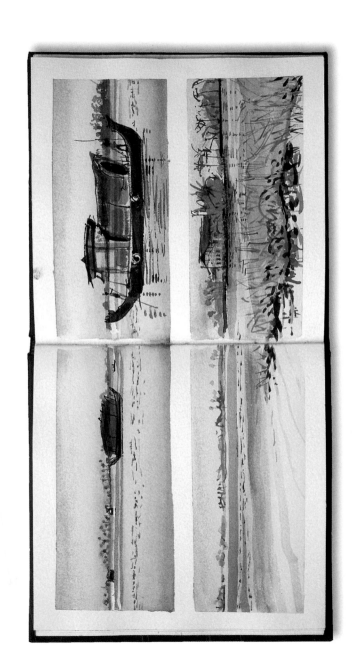

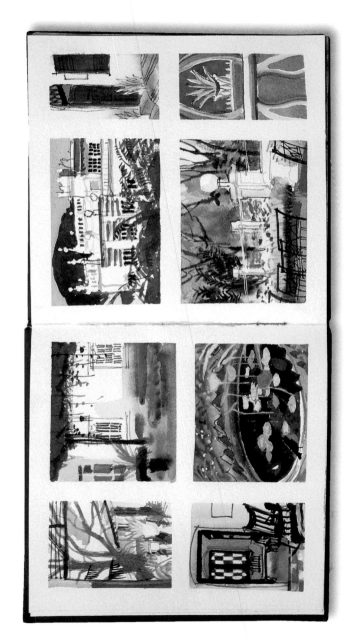

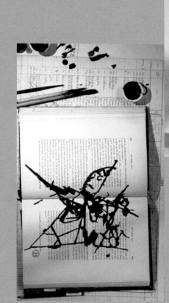
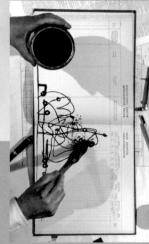

William **Kentridge**

DRAWING IS PREDOMINANT IN THE WORK OF SOUTH

African artist William Kentridge. He is well known for his large-scale set designs and projections for theatre and opera productions, as well as animation, films, installations, drawings and prints. He keeps a sketchbook in his studio and uses it on a daily basis for making notes and diagrams, rather than drawings. He calls this process 'thinking aloud'.

William has created a series of works using old, printed books where he draws directly onto the pages, over the text. He has used old ledger books, cooking manuals, language course books, maps and encyclopedias as vehicles for his concepts. When he embarks upon work of this nature, he carefully considers the intended drawing medium with the suitability and quality of the paper in the book. Will it take charcoal? Is it suitable for paint? Pre-19th-century pages have a texture ideal for charcoal dust and will result in a rich image. Some papers absorb Indian ink too readily, like blotting paper, while on the surface of other papers ink will pool and gradually evaporate, leaving a mark like a wash on a lithographic stone. He looks for a connection between the subject of the book and his concept. The relationship between the two can be tenuous and subtle. The part obliteration of the text matter creates a different, changed book, marrying the directness of drawings with old, commercial letterpress text.

A recent 'book with image' that William has created is the 'cat/coffee' book and a few of the spreads are depicted here. It is intended as a flick-book with the drawing of a coffee pot 'morphing' into a cat. William has used the structure of the book to conclude the sequence of drawings, with the cat disappearing into the centre fold. The processes of making the drawings and flipping the pages were filmed spread to create an animation. ▷

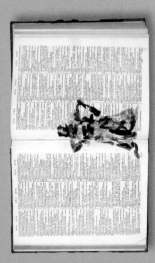
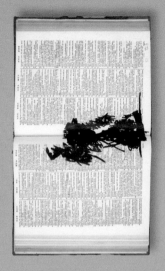
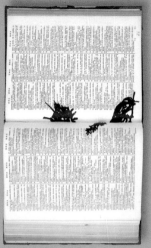
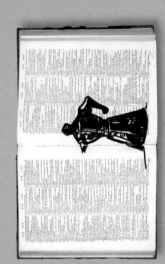
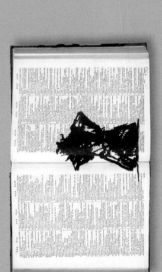
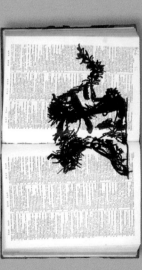

Selected spreads from William Kentridge's 'cat book' where a sequence of drawings on consecutive pages of a printed book were filmed spread by spread to create an animation; followed by works entitled 'ERPMS', 'Intoxicating Liquor 4', 'L'exploration du Sahara 7', 'Les Merveilles 5', and lastly selected works from his 2010 exhibition at the Louvre Museum in Paris.

In 2010, William had an exhibition in the Louvre Museum in Paris, where several of his books with drawings were displayed. Some of the images depict him in the process of creating the drawings in the large, printed books. These are stills from a film showing the construction of the drawings. He sometimes reverses the films, thereby deconstructing the artwork.

In William's early life as an artist he carried a sketchbook around on his travels and often brought it home unused, so now he doesn't take one out of his studio. He feels that this traditional sketchbook has been replaced by a video camera, which he uses for reference and to record the progress of drawings, etc., as they are created. He likens the replaying and re-filming with the action of turning pages of a sketchbook.

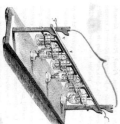

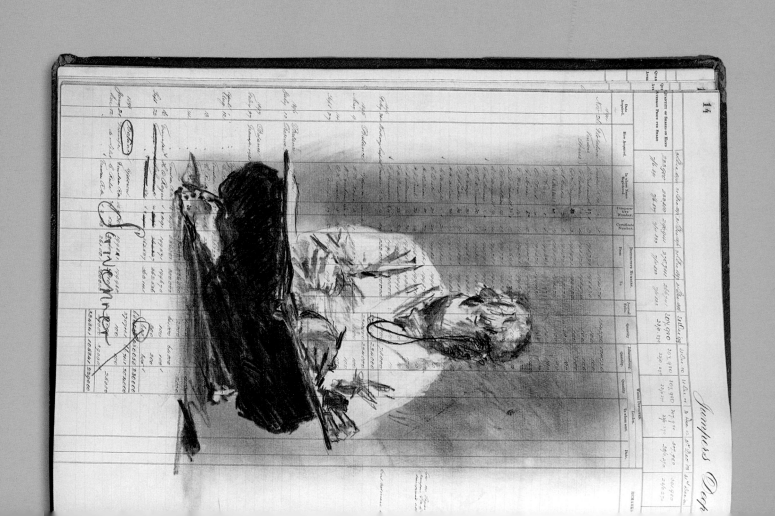

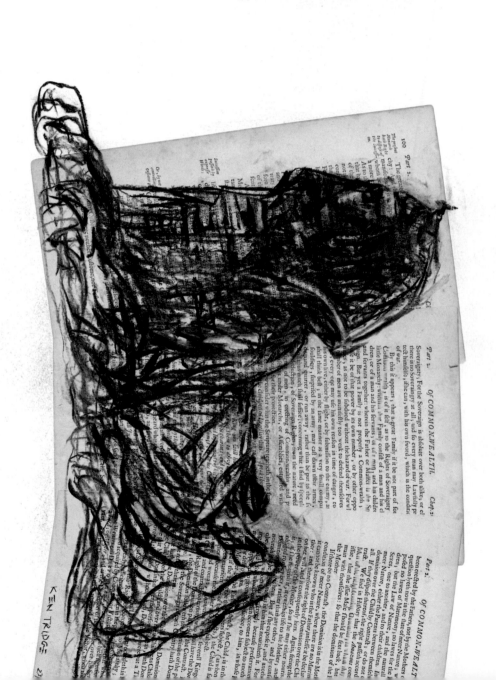

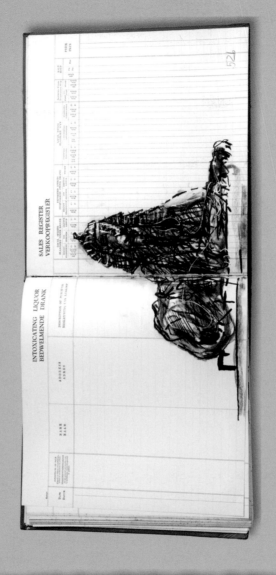

Liz **Boast**

ARTIST LIZ BOAST IS THE CREATOR OF MANY DIFFERENT
types of artwork. She paints, draws, and makes prints, sculpture and
installations. The main purpose of her sketchbooks is to document
her ideas, of which she has many, and to 'park them somewhere and
then come back, sort them, reject them, work from them.' Liz prefers
Moleskine notebooks as they are hardback, have good quality
paper and a pocket in the back for notes, cuttings or private view
invitations. Currently she has three sketchbooks on the go.

'The studio one is the most serious, and full of views from windows,
doodles for further development and drawings of all manner of
things. I use it when I feel itchy for drawing.' Her 'home' sketchbook is
that one that is least used, but there for emergencies such as being
snowed-in, or ill. The most important one for Liz is the smallest

book that travels everywhere with her and fits into her bag. On the
completion of a sketchbook Liz finds the changeover tricky. 'I still
carry the old one around with me until the new one is "settled in",

Like many of us, Liz feels that her sketchbooks are essential to her
final pieces and is constantly battling with problem of emulating the
freedom of this work, with that of her prints. 'I find the same subject
matter returns endlessly. In sketchbooks from my foundation course,
my degree and my Masters and all the years in between, there
are the same themes – hares (but not rabbits), feathers (but not
birds – well not many), dogs (but not cats), dolls, myths and stories.
They are getting more refined as I develop creatively.' Liz considers
her sketchbooks a 'trigger' for the work that she goes on to create,
but you would not necessarily make this connection from viewing
them. 'I saw Terry Frost's sketchbooks in the Tate at St Ives, U.K.,
they were beautiful! Very, very different from the final works but
contributed so well.' ▷

One of the benefits of having a top-floor
studio in an old mill is the view out of the
window. It overlooks the millpond with the
constant 'duck wars' or the sheep in various
states of woolly shabbiness. On most days
this will offer Liz an invitation for a drawing.

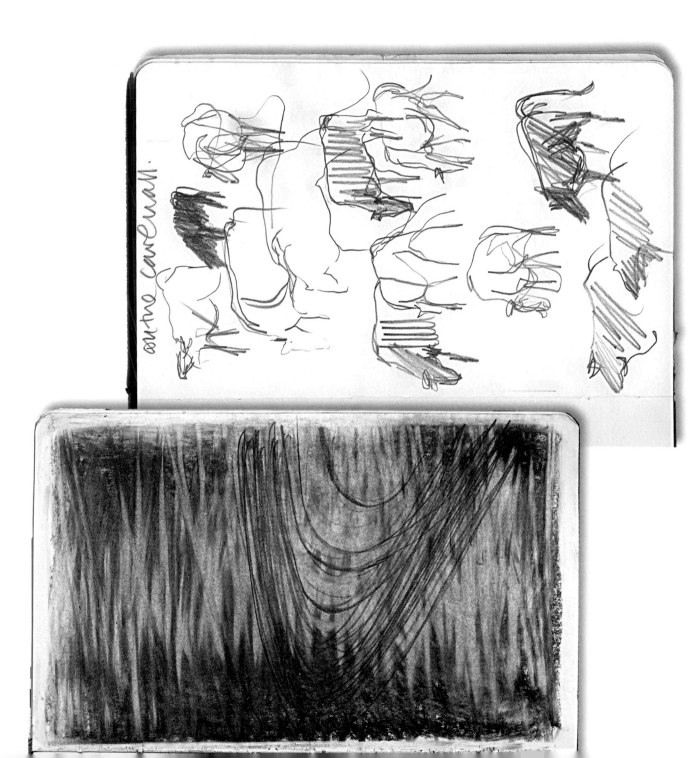

Liz recognises the importance of looking at the work of other artists, which cannot fail to enrich our own ideas and expand possibilities that may not otherwise have occurred to us. Recently she visited the Miro Foundation in Barcelona where she saw Calder's *Mercury Fountain*, and it made a big impact. 'I've seen it several times before but this time noticed *Guernica* (by Picasso) on the wall behind.' This painting has a special affinity for Liz, who has held an exhibition in Guernica. As well as making quick drawings in her sketchbook,

Liz makes notes about what she sees and where she visits on her travels, and always dates them.

'I sometimes sit and look through all of my books (even though I know what is in them), purely to remember what "it" is all about – this whole silly business that is making art – something that you can't give up.'

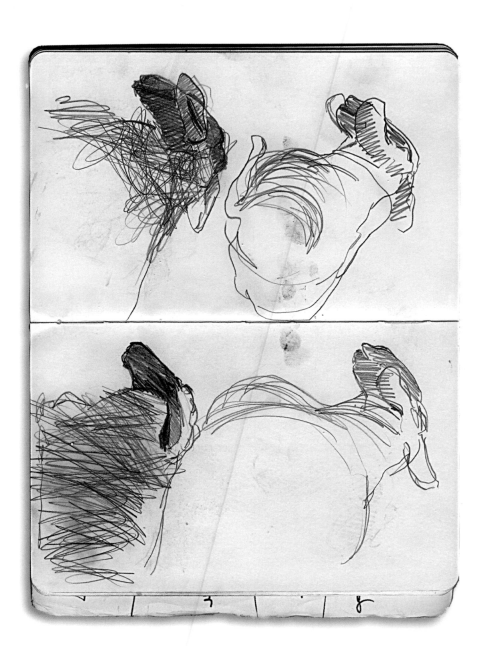

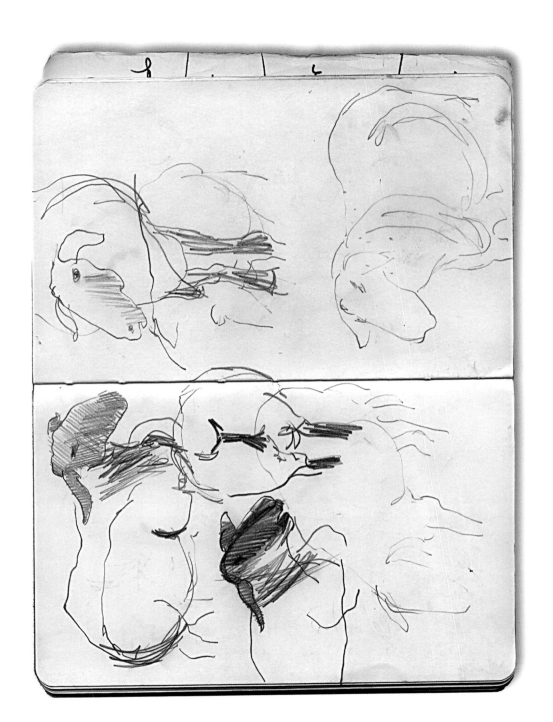

PAINTER AND PRINTMAKER CORINNA BUTTON BUTTON TAKES HER

ideas from 'seemingly ordinary happenings; people at their daily routines, a word or snippet of conversation, an advert in a magazine, a particular fabric, etc. These are triggers I frequently draw upon and use to express that which I feel is bubbling beneath the surface.' Having recently moved to Chicago, Corinna wanted to develop ideas that had been put aside during the upheaval, so is currently 'feasting off previous sketchbooks and developing some of the images into prints and paintings. 'A new theme will gradually emerge as I develop a sketchbook influenced by my new habitat. It will be an extension of a continuing theme – a fascination with people.'

Corinna **Button**

Corinna keeps several sketchbooks on the go at any one time, each for a different purpose. 'I carry a small one around with me most days, though I don't necessarily use it every day. It's there so I'm able to act on an idea immediately, before I forget. I've learnt from experience that this is really important, as even if I'm certain I'll remember a particular "brain-wave" – I don't. My ideas can appear initially as just scribble, a list of words or a very primitive line drawing with just enough info to remind me. Sometimes if I see a particular scene that intrigues or triggers an idea (nearly always featuring people) I might sketch the essential "bones" of what I see very discreetly; if I feel that I look too intrusive, then I'll slope off and try and put down as much as I can recall, in private.' ▷

'Seemingly ordinary happenings' in everyday life are the trigger to Corinna's ideas for paintings and prints. The images here demonstrate her view of the world and her exciting approach to image-making.

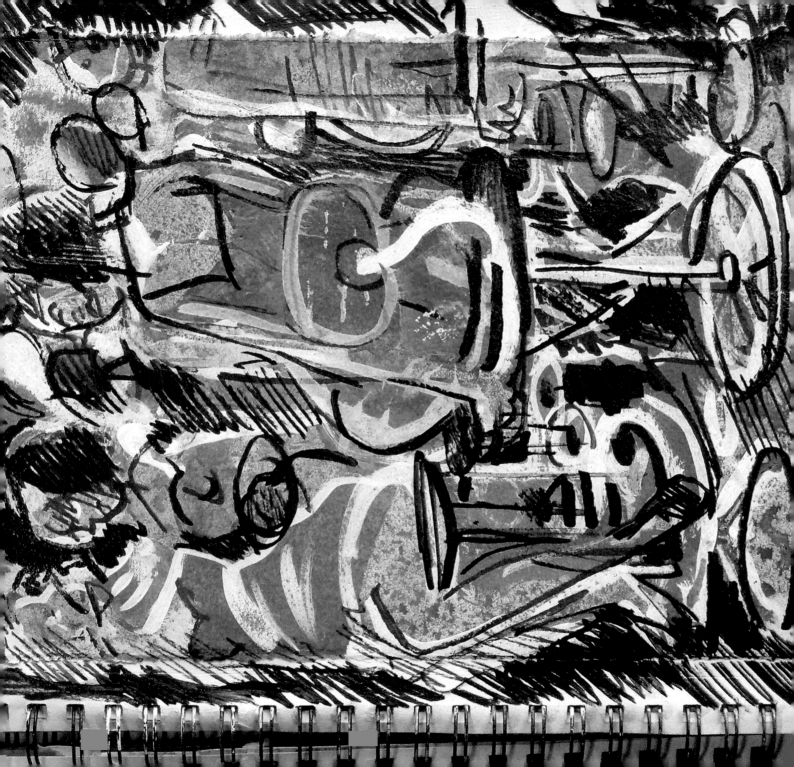

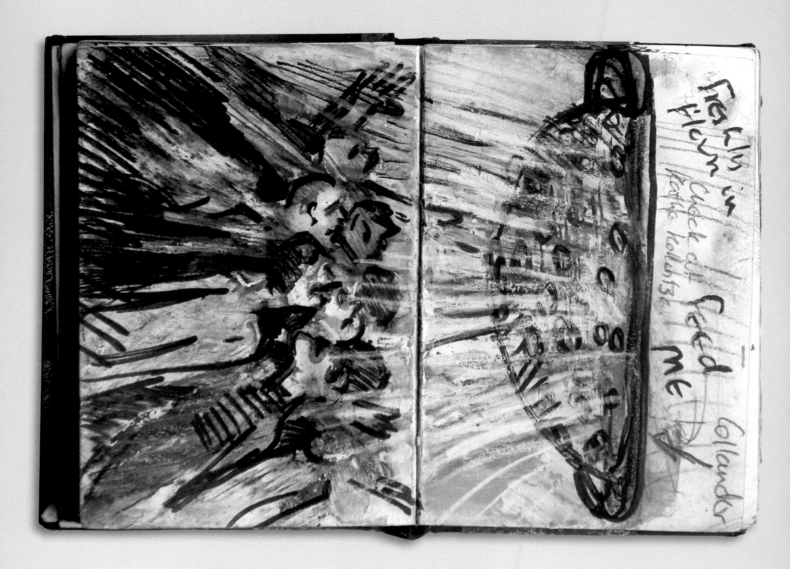

FEED
ME

Periodically, Corinna will take ideas further in a larger sketchbook and work them quite heavily. She likes to use textured white, robust cartridge paper books in her studio, and keeps a separate one for life drawing. 'In larger sketchbooks I sometimes prepare the paper of several pages in advance, by adding various background colour or textures. I coat the paper with a sandy mixture or layers of sprayed-on acrylic medium to give a granular texture and then work over these pages with all kinds of materials such as charcoal, pastels, acrylic paint and sometimes thinned oil paint, pencil/ graphite stick – a totally mixed media approach. Sometimes I use my printmaking

"proofs" taken from work in progress, to draw over, and experiment with. These can form a whole series in a sketchbook which is like a larder full of stock, to use and expand upon. I'll never get the chance to develop all the potential ideas that I've stored up.'

'I love going back through old sketchbooks with a "fresh" eye I find myself enjoying, reconsidering and being inspired by those earlier pieces that I'd considered "baddies" or "failures". It's always a rewarding journey.'

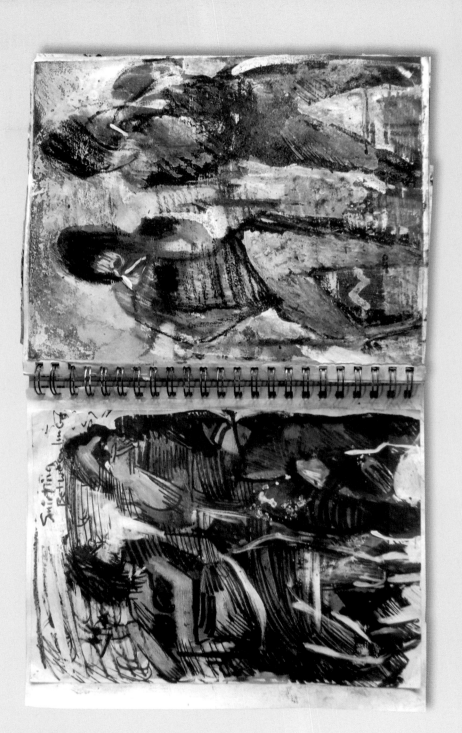

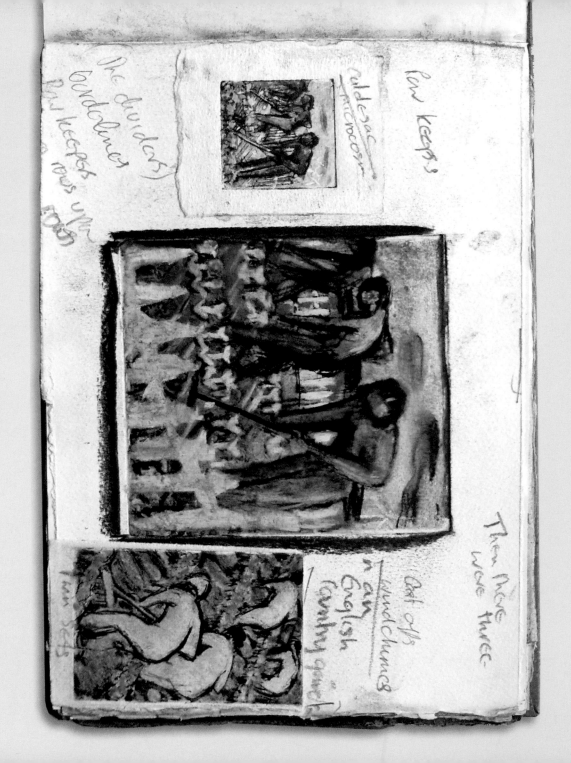

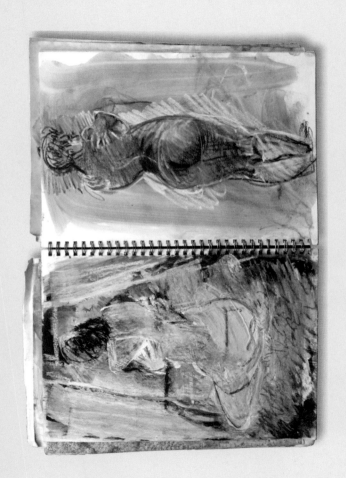

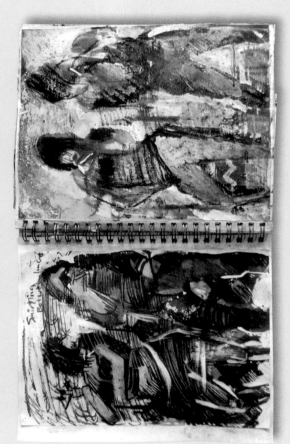

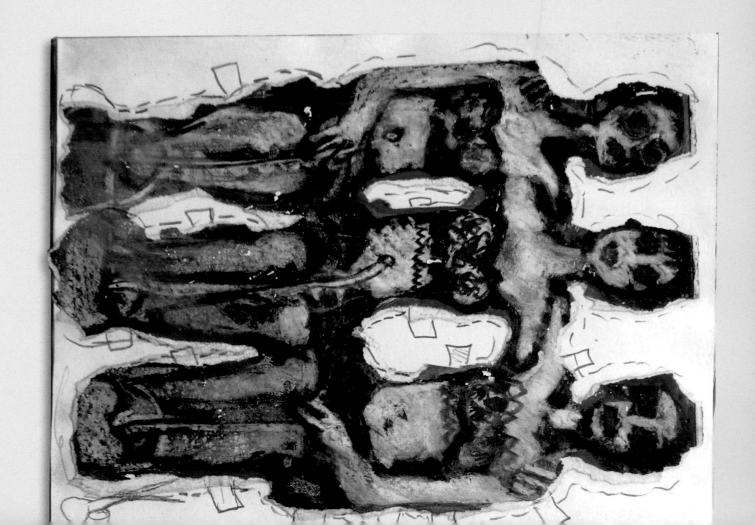

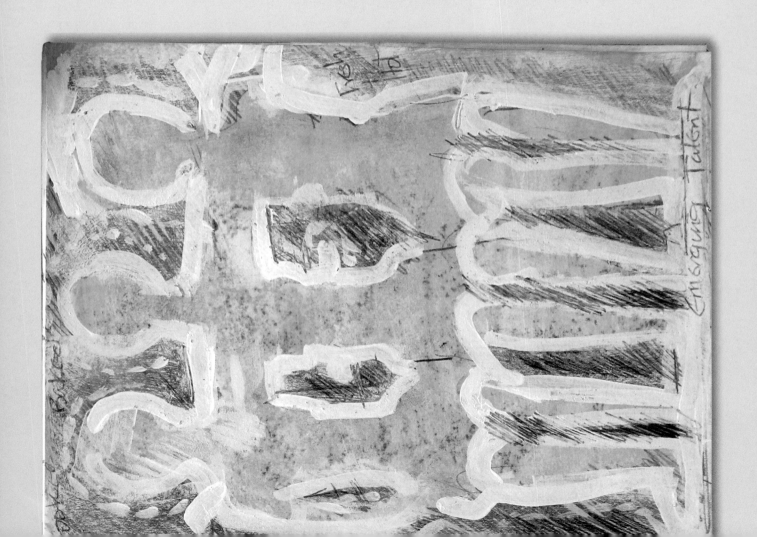

Henry Moore
1898-1986

I ALWAYS THINK OF HENRY MOORE AS BEING THE KING of the sketchbook, although he preferred the term 'notebook'. In his early career as an artist, he carried one around on his travels to document museum artefacts and make drawings and notes about possibilities for sculpture. Drawing was an essential part of Moore's practice as an artist throughout his long career.

In 1940, Moore effectively became an Official War Artist for Britain and made some amazing drawings of the people sheltering from the Blitz on the platforms of various London Underground stations. He didn't feel that it was possible to draw directly on the Underground platforms, so would often climb the stairs to make notes to himself on the back of envelopes. More elaborate drawings were carried out in his studio, after each visit. He filled two notebooks with these images, executed in pen and ink, watercolour and crayon. Moore sometimes drew with a candle, which he then washed over with dark watercolour, the candle wax resisted the paint to create highlights. A selection from these notebooks was later published in facsimile, entitled *Henry Moore – A Shelter Sketchbook*. In the same period, Moore made drawings of coal miners at the Wheldale Colliery in Castleford, West Yorkshire, where he was born. Both sets of work highlight the artist's fascination with the reclining figure.

In 1972, when Moore's sculpture was being packed into crates for a major exhibition in Florence, he retired to his studio and filled a notebook with studies of the sheep that he could see from the window. They were drawn in ballpoint pen and were further developed into prints (etchings and lithographs) and small sculptures. This notebook was also published in facsimile, entitled *Henry Moore's Sheep Sketchbook*.

Moore was a prolific artist. In addition to sculpture, he produced thousands of drawings and prints as well as designs for printed textiles and tapestries. Many of his ideas started as drawings and many of those drawings were made in his notebooks. The examples shown here are from two early examples of Moore's drawing books. He liked to crowd his pages with images, one idea leading to another. It is interesting to see his reclining figures applied to a design for a printed textile. Some of his books survive, although many of the pages have been removed. He liked to include drawings in his sculpture exhibitions and so pages were sometimes extracted for framing.

Moore felt that the speed of drawing was the perfect complement to the slow process of creating sculpture. Increasingly he considered his drawings a separate activity from his other work – a creative practice in their own right. At the Henry Moore Foundation at Perry Green in Hertfordshire, UK, one can begin to gauge the immense creative output generated by this exceptional artist.

Textile Design: Reclining Figures 1943
Page from *Textile Design Sketchbook 2*
HMF 1310
254 x 178mm
pencil, wax crayon, watercolour, pen and ink on cream medium-weight wove
signature (added later, misdated): pencil l.r. *Moore/37*
photo: The Henry Moore Foundation archive

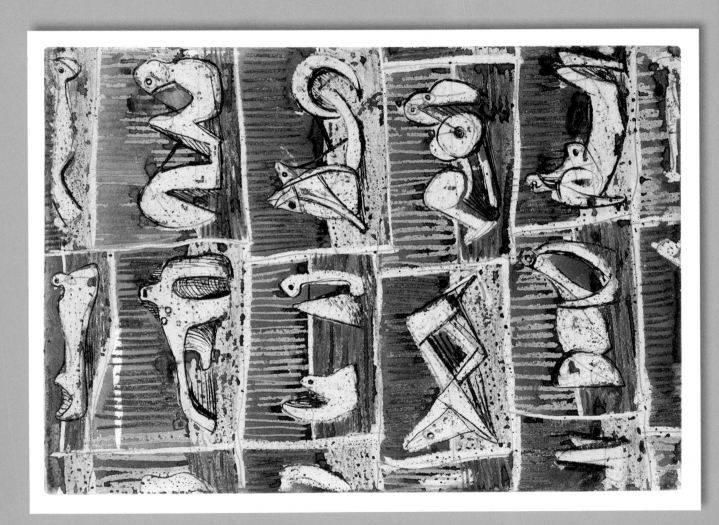

Sally **Finning**

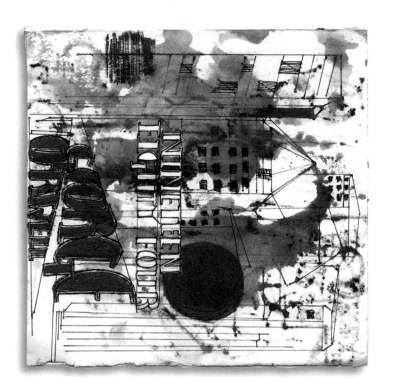

RECENT BA GRADUATE SALLY FINNING SPECIALISED IN
illustration on a media degree course that was structured as half-
theory and half-practice. She got into the habit of developing all of
her finished artwork via her sketchbook, which she used at home,
at college, on the bus, on the telephone or on her travels. 'I find that
an "unconscious" approach to drawing loosens control and allows
a greater lucidity to the images I draw. If I am talking to someone,
or splitting my levels of concentration between two activities, I
discover a sense of freedom and the images pour out.'

Sally likes to work in hardback, ring-bound A4 or A5 sketchbooks
and uses them to draw, to jot down any influences, recommended
galleries and miscellaneous notions relating to her current work.
They are also portable, which is important because of the continuity
of thought that she likes to maintain. Sally prefers the texture
of watercolour paper, which offers the option of adding colour
with ink or watercolour paints later on. At college, she discovered
a sketchbook of brown wrapping paper, which she found to be
complimentary to her drawings. 'To work on a non-white paper
added a deeper dimension to the image and the option of adding
white for highlights.'

The sketchbooks that Sally used on her degree course did not
only include drawings. As her depicted examples demonstrate,
she experimented with printmaking for the illustration of George
Orwell's novel *Nineteen Eighty-Four* and she "proofed" her linocuts
directly onto her sketchbook pages, playing with overlapping
imagery and varying amounts of printing ink. Since graduating, Sally
has carried out freelance illustration work and all of her research and
design for this, took shape in her current sketchbook.

'My sketchbook provided a platform to alter my initial ideas to
suit a niche older fashion market, whilst also broadening my
understanding of fashion illustration. This particular commission
was for a fashion entrepreneur who is developing a new design
business. Colour experimentation within the sketchbook also
supported the realisation of a subtler, more modest look which
would support the target audience.'

Sally's sketchbook depicts some of her initial
ideas for a college project to illustrate the novel
Nineteen Eighty-Four by George Orwell. She
considered a combination of approaches that
included drawing with printmaking.

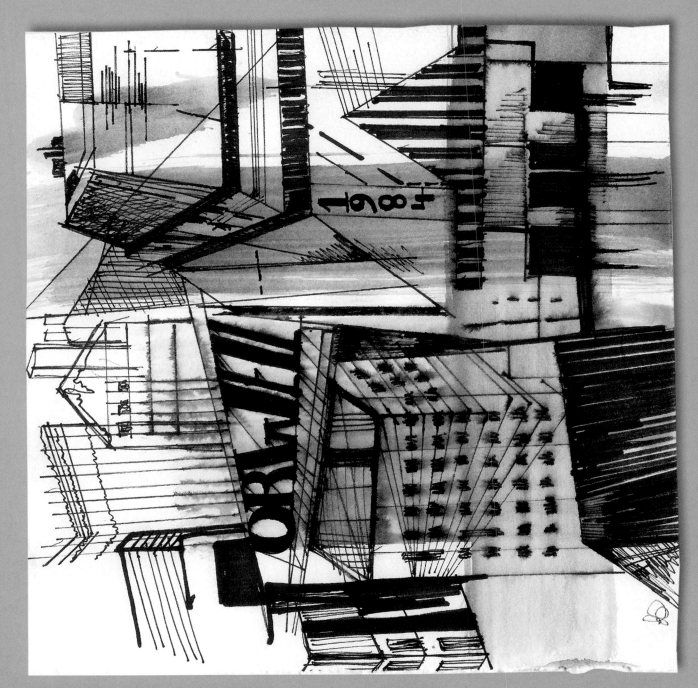

THE IMAGE was
firstly sketched,
then photocopied
onto tracing
paper.
I then passed
a yellow chalk
over the tracing
paper to ingrain an
outline of the rat
onto lino.

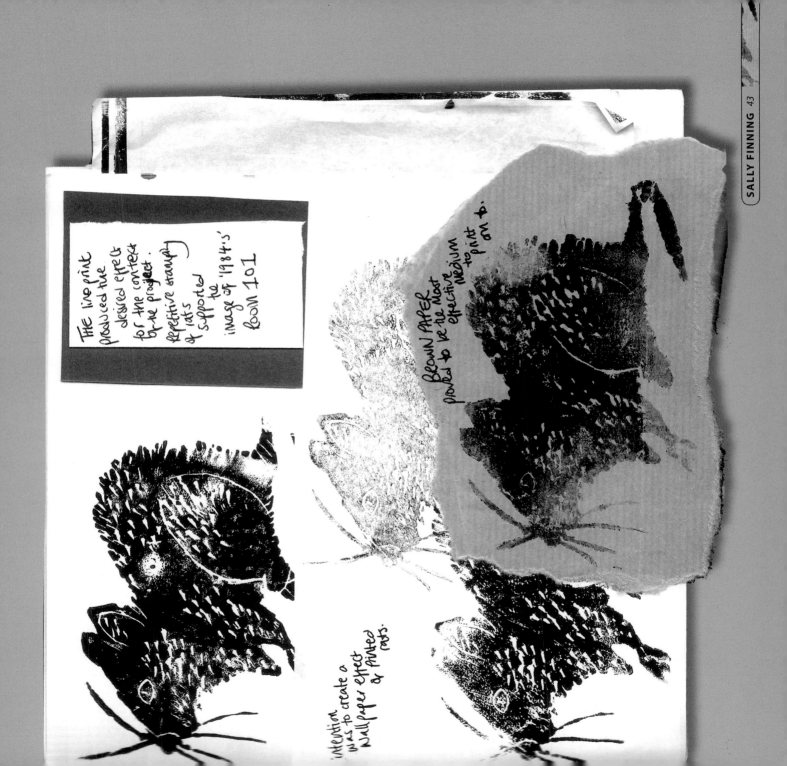

THE lino print
produced the
desired effect
for the context
of the project.
Repetitive imagery
of rats
supported the
image of '1984's'
Room 101

BROWN PAPER
proved to be the Most
effective Medium
to print on to.

intention
was to create a
wallpaper effect
of printed
rats.

Richard **Bell**

WILDLIFE ILLUSTRATOR AND WRITER RICHARD BELL SEES his sketchbooks primarily as drawing journals and he works in them every day. 'The current three are a small travel book, an A4 landscape format, which is mainly for natural history and a six-inch-square spiral-bound book for everyday; that's the one that's in my small art bag, which I grab every time I go out.' His sketchbooks are central to his creative output. On location he likes to work in a black or brown fibre tip pen (Pilot drawing pens in various nib sizes) or a Rotring Artpen with a sketch nib, filled with Noodler's waterproof brown ink, plus a ten-colour watercolour box and a Pentel waterbrush.

Richard's interest in documenting the natural world goes back many years. 'I've still got an exercise book of nature notes, illustrated in pencil, pen and coloured pencil, which I wrote aged eight or nine. I kept increasingly elaborate illustrated holiday diaries as a teenager but it wasn't until my art school days, after college each evening on my local patch of countryside and during spells as a volunteer warden in a bird reserve, that I got the chance to keep a drawing journal. This eventually developed into my first handwritten sketchbook publications *A Sketchbook of the Natural History of the Country Round Wakefield* and *Richard Bell's Britain*.' ▷

A selection of pages from Richard's sketchbooks, showing studies made on location during walks in his beloved Peak District National Park.

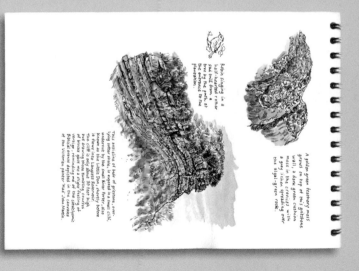

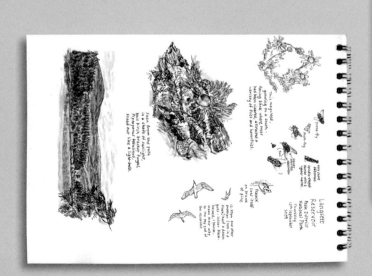

The Strands

Monday, 11th October 2010, 1.50pm

A covey of grey partridges has just flown up from the Strands which is a marshy field between the River Calder and the Calder & Hebble Navigation.

The partridges — about ten of them — have settled in the winter wheat in the field below Strands Farm.

On stump

Stagshorn or candle-snuff fungus

Washed beetroot Burnt Plum

white stem

Russula

fly

← 5cm →

Fungi beneath birches

These earthball fungi and two kinds of toadstool are growing in a strip of silver birch woodland between the canal & the Wyke.

6cm across

Three herons stand close together at the edge of the small flash on the Wyke. A cormorant flies over. A crow (or jackdaw?) skirmishes with one of the gulls.

A yellow crusty lichen — Lecanora or Xanthoria, I guess — grows on a stub of an elder by the towpath.

'I realise that I'm at my happiest when I'm looking outwards, rather than inwards and away from culture rather than towards it. Because of this, I don't really see my sketchbooks as 'art' as they represent a continuing investigation of the world around me. I enjoyed meeting up with other artists on a "city sketchcrawl" in Sheffield recently but rather than spend the day in Sheffield, welcoming and full of potential subjects as it is, I'd always prefer to have several hours time out in the Peak District National Park just five miles west of the city centre where I can always find something – flower, fungi, rock, landform – that I've never drawn before. This seems to me to have a greater depth of meaning than the coffee cups, bricks and concrete that I might find myself drawing as backgrounds on a sketchcrawl in the city.'

Richard is always interested to see other people's sketchbooks and has found Frederick Franck's Zen of Seeing (1973) to be significant for him, 'because he suggests that there's more to the drawing habit than picture making. Also, New Yorker Danny Gregory gives a personal slant on how drawing can become a vital part of your life in his Everyday Matters' (2003).

His sketchbooks are mainly for himself, but Richard is not secretive about his drawings 'One or two people get to see the sketchbooks when I'm out and about but most of the drawings go online in my blog, www.wildyorkshire.co.uk'

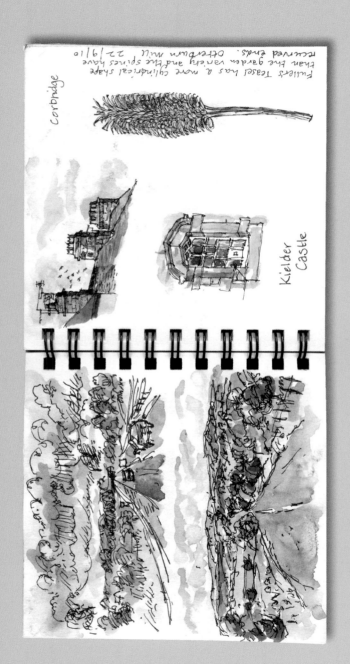

Corbridge

Fullers Teasel has a more cylindrical shape than the garden variety and the spines have recurved ends. Otterburn Mill 22/9/10

Kielder Castle

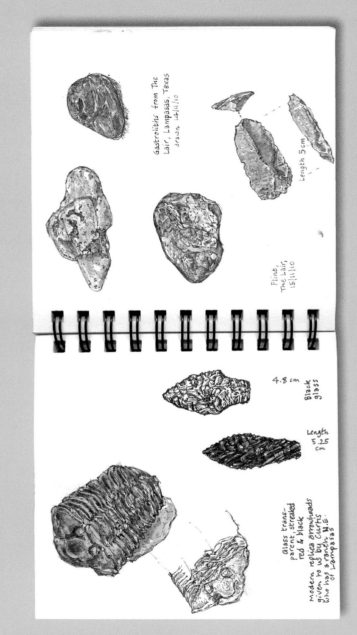

Gastroliths from The Lair, Lampasas, Texas drawn 14/11/10

Length 5 cm

Flint, The Lair, 15/11/10

4.8 cm Black glass

Length 5.25 cm

Glass transparent, streaked red & black

Modern replica arrowheads given to us by Curtis who has a ranch N.E. of Lampasas

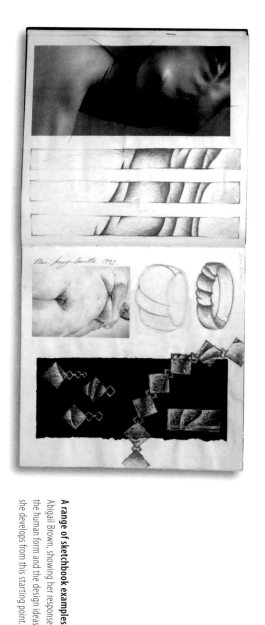

Abigail **Brown**

SILVERSMITH ABIGAIL BROWN USES HER SKETCHBOOKS

to help her consider form and technique and to record ideas for future work. She is inspired by structures of the body and also looks for pattern and texture as sources for her ideas. 'I often use images from fashion or interior design magazines and draw my ideas over the pictures. Sometimes I stick in blocks of coloured paper to break up the page'.

When she was a student, Abi found sketchbooks quite intimidating, knowing that the tutors and her peers would scrutinize them. She remembers being concerned about making mistakes. Now she often uses her books as teaching aids when she is discussing design methods with students. 'I try to encourage them not to be afraid of the white paper as I once was, and give them techniques to break up the page in a constructive way so that it becomes easier to enjoy the process of developing ideas.' ▷

A range of sketchbook examples by Abigail Brown, showing her response to the human form and the design ideas that she develops from this starting point.

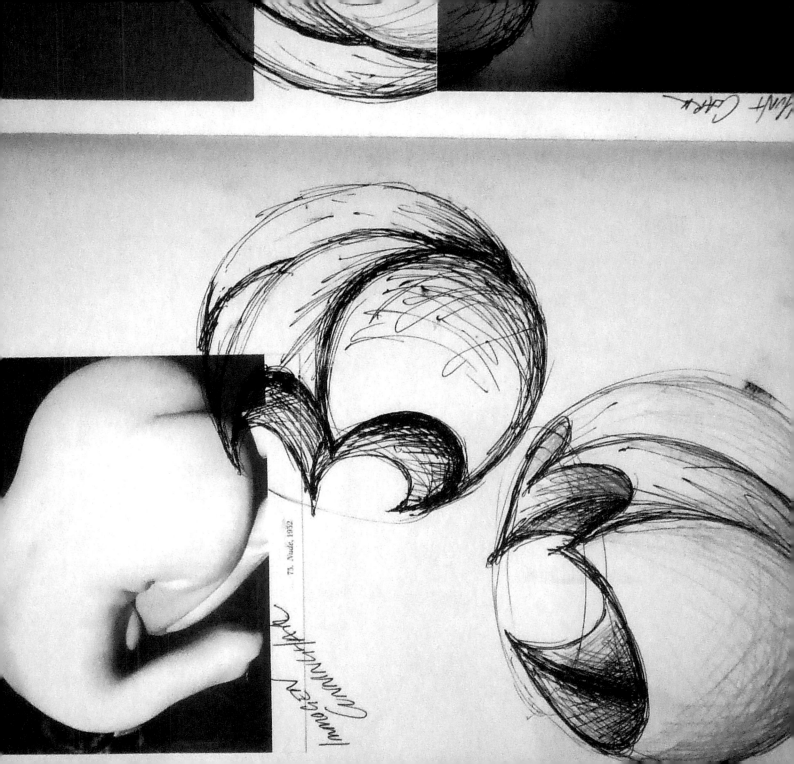

'As a practising craftsperson a lot of my design work is done directly at the bench with component parts from other pieces. I specialise in a hand raising and sinking technique to create distinctive contemporary silver vessels, bowls, boxes and jewellery, based on the human form.'

Currently Abi is in Nepal working for a charity, teaching deaf adults and survivors of child trafficking to make jewellery so that they can generate an income. She has taken sketchbooks with her and is using them to record her experiences there. 'This is a wonderful opportunity to draw for pleasure and to document the trip, and it will hopefully lead to new design work in the future.' She is attempting to draw for 15 minutes every day. This is a new approach for Abi and she feels that this unique experience will give her the opportunity of improving her drawing skills. 'I have generally used my books for design purposes directly relating to my craft but now I would like to use them as a new creative outlet that is not necessarily, immediately associated to my metalwork.'

'I am no longer so attached to the finished outcome of a sketchbook; the enjoyment and fulfillment for me is in the process of creativity, whether that is drawing or working in metal. I am striving to get back to drawing and using a sketchbook for pleasure and not merely for design, so this is the aim for my current book whilst in Nepal.'

Abi's next travel adventure will be as resident artist in Alaska. This will offer her another amazing sketchbook opportunity, of recording and responding to a unique location.

Mark **Gamsu**

MARK GAMSU DESCRIBES HIMSELF AS 'BUREAUCRAT IN
the civil service' and he has made drawings and relief prints for
over 30 years. As his work pressure has increased he has started
to use a sketchbook to record what he sees and sketch on the
move.' Three years ago he discovered a little Moleskine book
with an integral pocket at the back, providing just the place to
keep a propelling pencil, and small enough to carry around in his
jacket pocket. Mark always uses a 2B lead. Nowadays he never
leaves home without his book and uses it whenever he can. 'I get
withdrawal symptoms if I miss a day.'

Many of Mark's drawings are made in coffee bars if he can get a
good seat inside that enables him to study the queue, or sit at a
window with the view of an active street scene outside. 'Some of my
favourites are Cafe Nero near Manchester Piccadilly – lots of people
crossing the road; Starbucks on Fargate in Sheffield – good view
of the pedestrian precinct; Cafe Nero in the Cut in London – great
queue; Cafe Nero on the Headrow in Leeds. I also like markets – the
problem here is getting a good seat.. and I do feel I need to be more
careful and respectful here – it can feel much more voyeuristic.' ▷

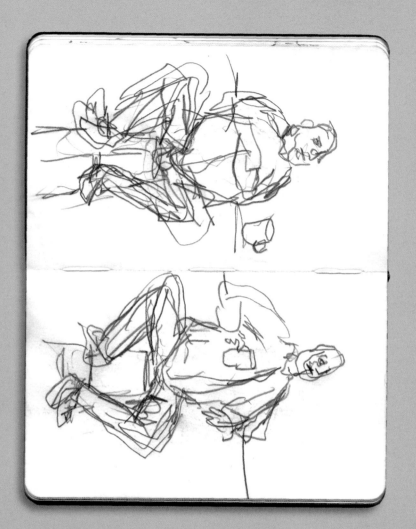

Mark's sketchbook accompanies him
everywhere he goes. In his 'café drawings'
he attempts to capture movement and
momentary stance. The drawings offer many
possibilities for his linocuts and woodcuts.

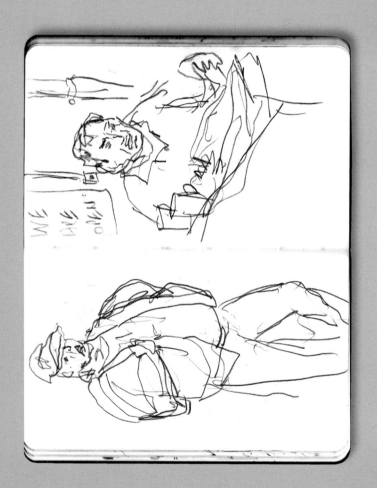
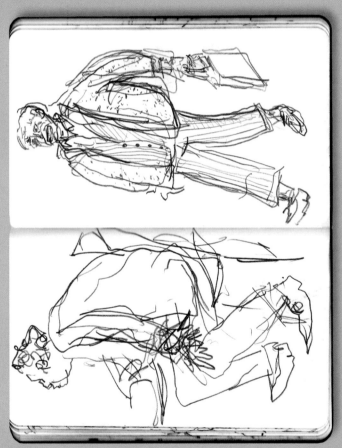

His sketchbook work is the source for all of Mark's relief prints (linocuts and woodcuts). He enjoys the challenge and immediacy of drawing on location where he attempts to capture movement and momentary stance. 'The style I am trying to cultivate is really loose and impressionistic. I am least relaxed when I try to exactly replicate what I see. One of the things that really excites me is when I spot the way that people hold themselves and I love it when I see someone standing with their weight on one leg, their legs crossed, or their arm bent and their hand resting on their hip with their fingers tucked into their palm. Being able to capture this can sometimes bring my images to life.'

Whilst being selective about which drawings he chooses to develop into prints, Mark's sketchbooks offer him an array of possibilities for further consideration. His lively drawings act as a reminder of a time and place, and the character of the people that he has drawn. In the process of cutting a block and printing it, his images undergo a transformation. He does not attempt to replicate his drawings, but allows the lino or wood to lead him onto a new sort of image.

Mark is inspired by the work of Leon Kossoff, Robert Crumb, Billy Childish and Quentin Blake.

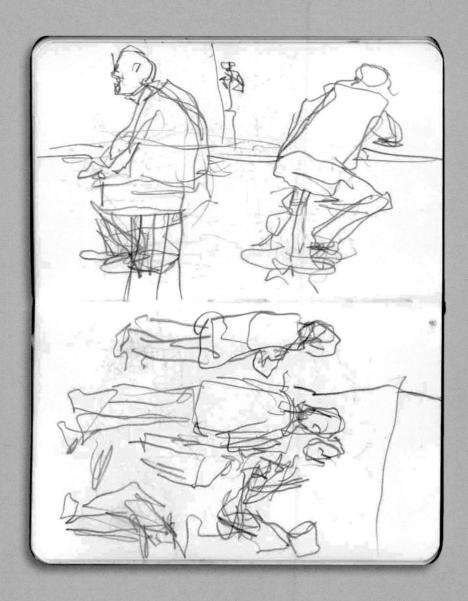

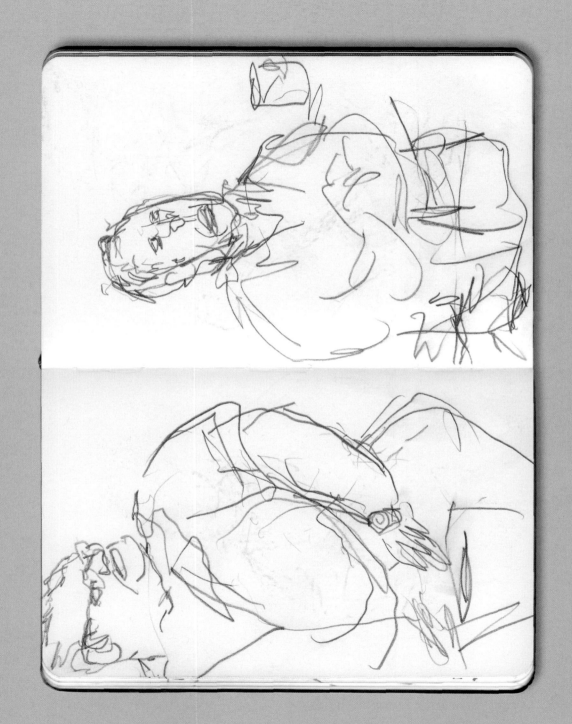

Karen **Butti**

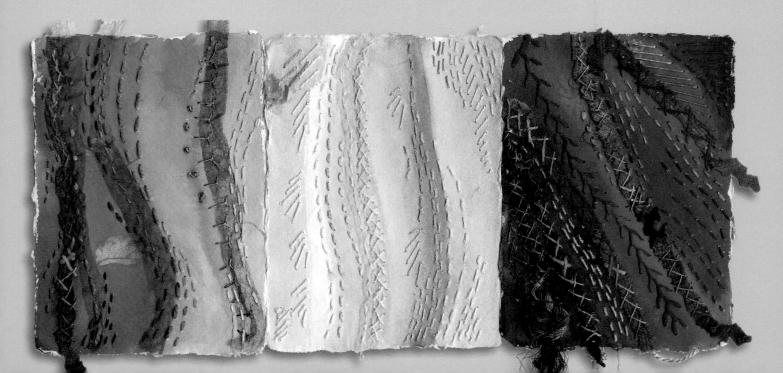

ARCHITECT KAREN BUTTI IS AN INVENTIVE KEEPER AND maker of sketchbooks. 'They are a way of engaging with the visual world: to see, to remember and to develop ideas. Looking back through them can concentrate memory of place, smell and sound from the time I was drawing. I can't imagine not having sketchbooks on the go for the rest of my life in some form or other.' Karen's sketchbook work informs her design ideas; she is a passionate embroiderer.

As time has gone by, the relationship between Karen's sketchbooks and her textile work has grown closer. She has worked embroideries that look as though they are pages from a sketchbook and sketchbooks that are embroidered. She has become increasingly interested in the interface between fabric, paper and stitch and often includes parts of architectural drawings and maps in her sewn work. 'I am naturally drawn to these materials and because there has been a lot of mixed media work in textiles created recently, to see and be inspired by.' When first she came upon the sketchbooks of Jan Beaney and Jean Littlejohn they made a big impression on her own approach to sketchbooks and embroidered pieces.

For research drawings and the development of her ideas Karen favours A5 or A6 books, which are small enough to carry about in her pocket or bag. 'I like quite heavy paper as I tend to use watercolour or water-based dye for colour, glue things in and sometimes to stitch directly into the pages of my book. I have recently had a few Khadi books which are good for stitching, as the rag content prevents the paper from tearing.' ▷

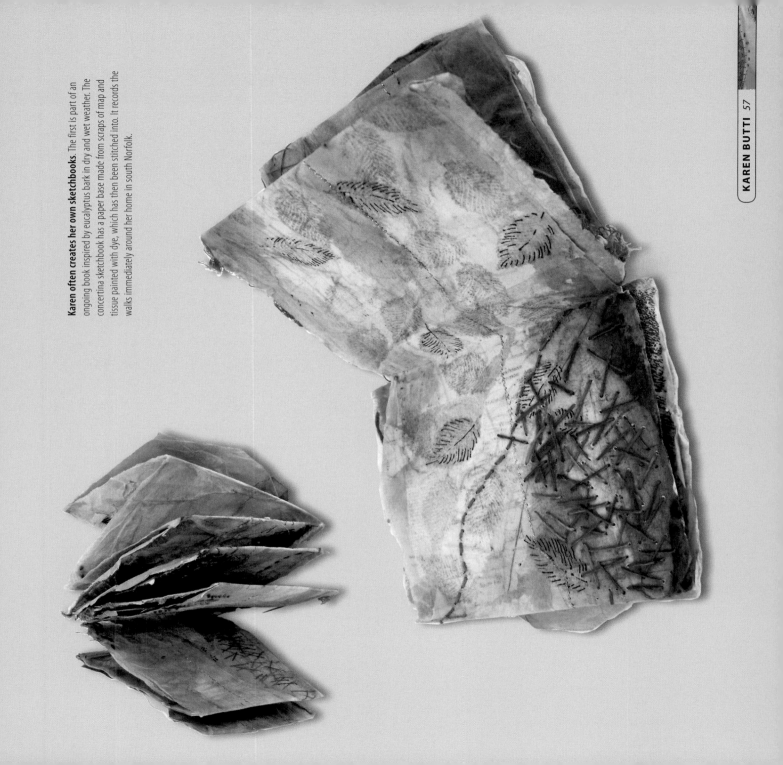

Karen often creates her own sketchbooks. The first is part of an ongoing book inspired by eucalyptus bark in dry and wet weather. The concertina sketchbook has a paper base made from scraps of map and tissue painted with dye, which has then been stitched into. It records the walks immediately around her home in south Norfolk.

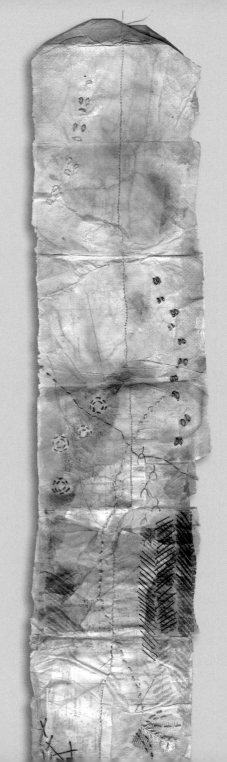

When travelling Karen can easily fill a sketchbook with lots of little two-to-five-minute visual notes of the things that attract her attention because they are new/foreign/pretty/funny. 'Typically, if I am sightseeing, I will do lots of sketches in the day and colour some of them in later from notes I make at the location.' For colour notes she has an ancient watercolour field box and a cheap set of water-based dye blocks, which give more vibrant colours if required. They allow her to colour fabric and thread when drawing on location.

Currently, Karen is working in five books, but all of her sketchbooks are current in the sense that she will sometimes go back to old ones and add new material retrospectively. 'They are principally for myself, although I have got used to the idea that fellow embroiderers and some family members are interested and like to look at them. I don't write anything in them that I wouldn't be prepared to say. I like it when a couple of pages look good in their own right, but am comfortable with the idea that everything goes in, "mistakes" and all.'

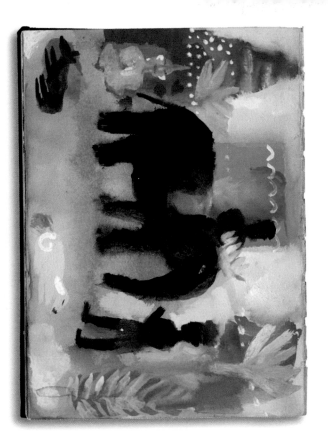

Christopher **Corr**

ILLUSTRATOR CHRISTOPHER CORR MOSTLY USES
sketchbooks when he's abroad, to draw what he sees and wants to remember. 'I like to buy the sketchbooks I use in the places where I am travelling. It adds to the experience and to the act of recording. In India, Nepal, China and Japan I have found and bought beautiful books with wonderful paper to work on. In some places it's hard to find an art shop or a stationery shop so I've worked in school exercise books, diaries and once a receipts book and a waiter's notepad.'

Chris trained in illustration and graphics and he also paints for exhibitions. He thinks that a sketchbook is a good way of keeping a stock of images together. Each of his travel sketchbooks becomes 'the official study' for that place, with it's own story and character. He also uses them to develop ways of working with new materials. ▷

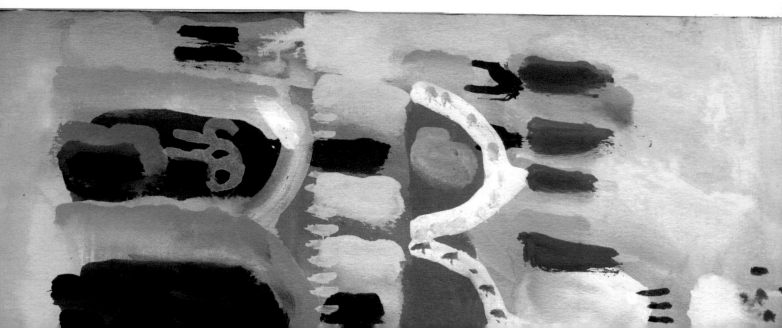

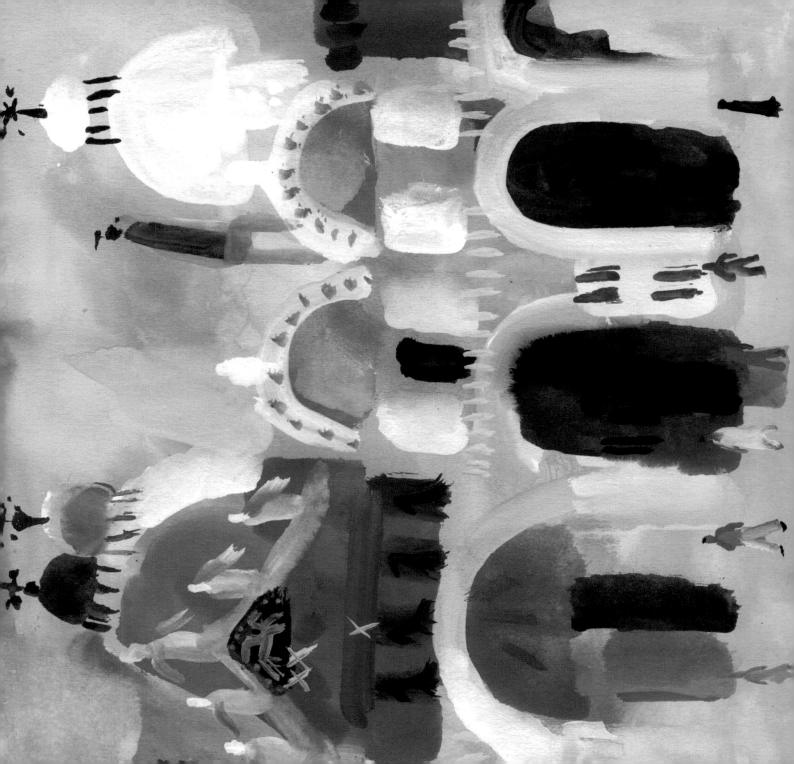

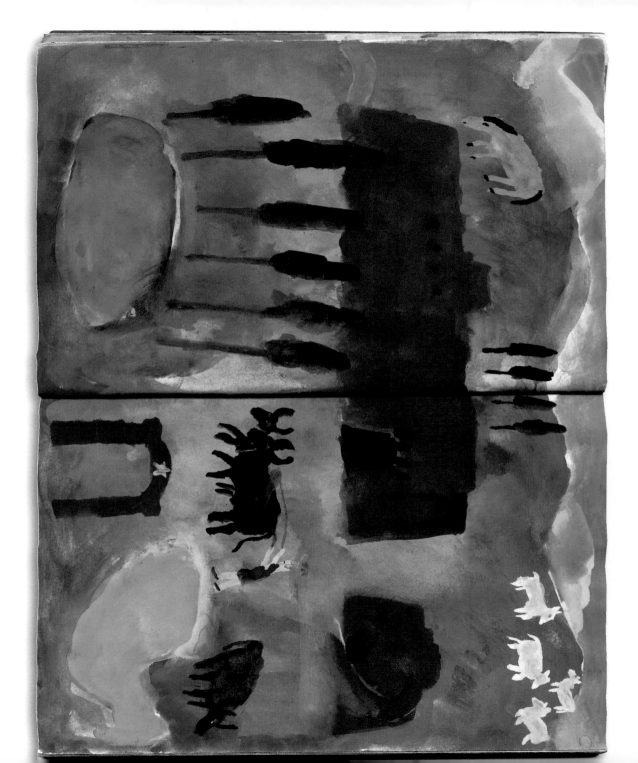

'When I was a student at Manchester Polytechnic I started using sketchbooks and spent a whole year working on location around the city, drawing everywhere and everything. It was the only way I could work.... I don't know why. But I really valued the privacy it allowed me... like a diary where I could record my thoughts and express ideas. It was good training for later times when I travelled abroad. I feel so comfortable working in them that sometimes I draw as I walk. I like long journeys too where I can draw the view out the window of a train, bus, car or plane. Recently I saw a young and elegant woman walking along Euston Road smoking a pipe. It was a perfect picture. I stopped right there and noted it down.'

Chris recently moved to the old City of London and that's the subject of his current sketchbook. He was in New York in the summer and painted the skyline in a new concertina book. 'I didn't complete it but I will take it with me on my next trip there and continue the job.'

The exciting sketchbooks of Picasso and Emil Nolde, as well as Paul Hogarth's travel journals have all influenced Chris. 'A sketchbook is a safe and respected object to work in. People don't feel hostility towards them as they might if you use a camera. In India lots of people asked me to draw them when they saw me working in my sketchbooks, and gave instructions about how they would like to be "picturised". "Make sure you paint my watch, and don't forget my moustaches." Another time in India I found myself completely surrounded by a crowd of onlookers and somebody gave me a cup of coffee but I could hardly move. The coffee spilt all over my book but another person took the sodden book to a nearby café and dried it in their oven.'

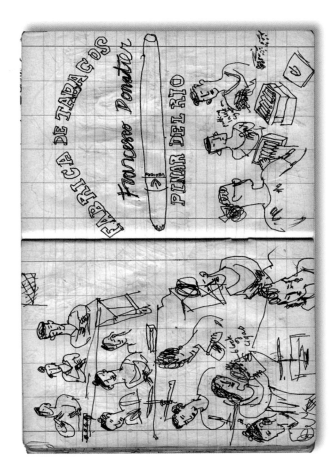

These examples are selected from Christopher's many travel sketchbooks: China Desert; Cuban cigars; Elephant; India; Landhaus, Berlin; Neues, Berlin; New York; NYC – Mexico; Opera House night; San Marco.

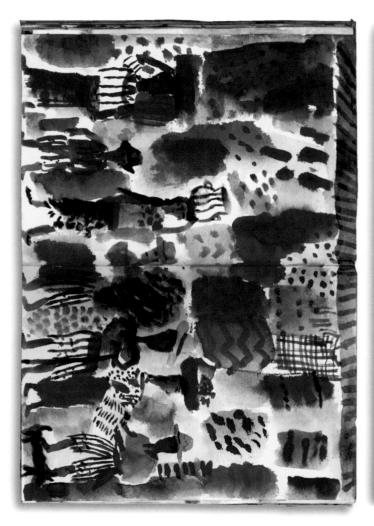
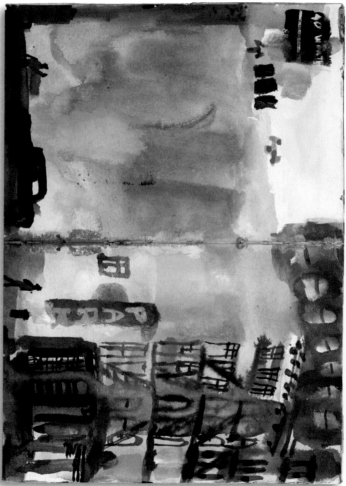

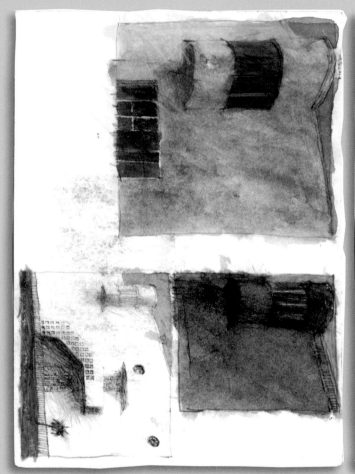
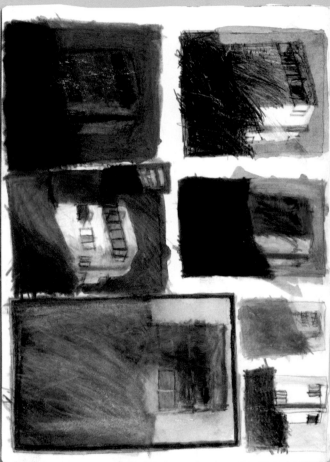

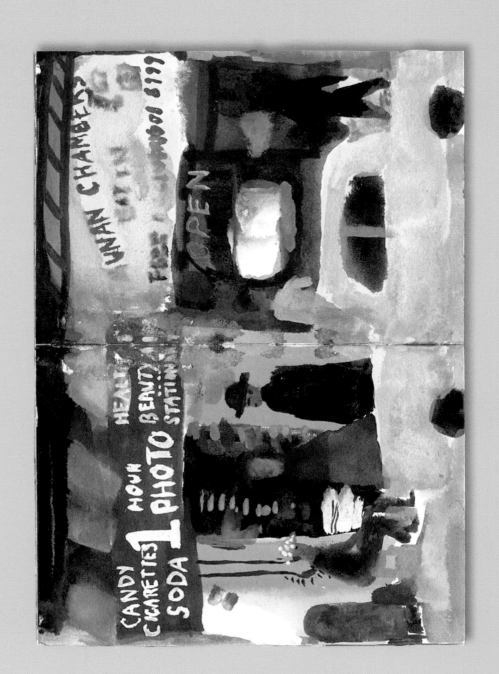

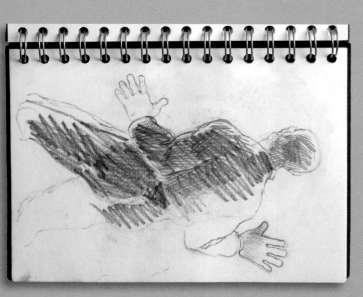

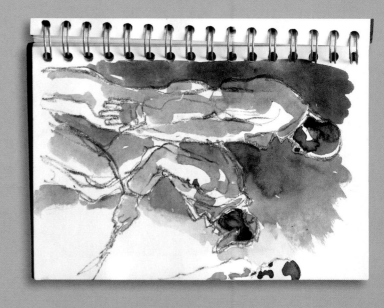

Jane **Stobart**

ARTIST-PRINTMAKER JANE STOBART USES AROUND FIVE
sketchbooks at any one time. She works in one or other of these
almost every day, 'to keep my ideas alive'. Jane's images usually start
life at industrial locations where she carries out visual research.
She has made drawings of people working in sewage pumping
stations, a bell foundry, a gin distillery, a London Underground train
maintenance depot, construction sites, etc. For this she uses A3
ring-bound cartridge drawing books which are discreet enough to
avoid getting in anyone's way, but big enough to make valuable
research drawings.

She also has a small hard-back, lined book that she takes
everywhere. 'It's good for working out initial ideas for prints and I use
it on tube trains, in waiting rooms and cafes. Most of my print ideas
start life in that book.' In her workshop Jane has several ring-bound
sketchbooks on the go, using one for each set of prints that she is
planning. These are used to develop ideas – a bridge between the
A3 research drawing books and the small 'ideas' notebook.

For drawing on the move Jane uses a couple of propelling pencils
that hold a 5mm lead, one sepia, one black. In her workshop she
uses mainly pencil and watercolours, which is an excellent way of
planning for aquatint prints. 'I also sometimes draw with a candle to
establish highlights, and the wax rejects the watercolour that I add
later. This is a method inspired by Henry Moore, whose drawings
and sketchbooks have had an enormous influence on me. Anthony
Gormley has also been inspirational. I read that he draws every
evening; I thought this a great idea and attempt to do the same.' ▷

These examples are from a range of Jane's
sketchbooks. They show location drawings and
ideas for etchings and woodcuts.

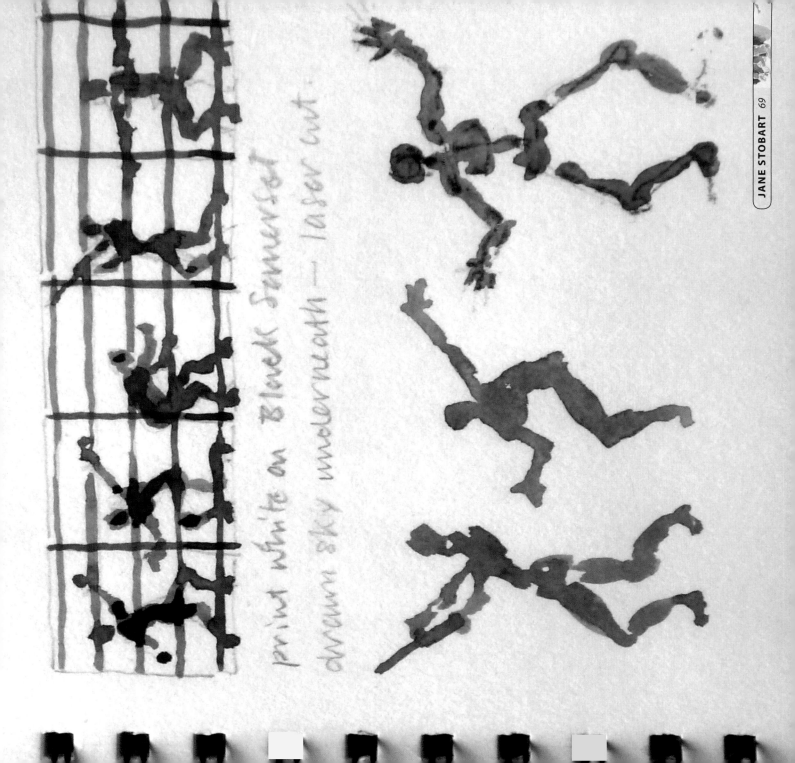

print white on Black Somerset
drawn sky underneath — laser cut.

Currently Jane is working around the subject of glaziers inspired by a period spent as artist-in-residence at an Essex college, where she produced sketchbooks on the construction site of a new arts building. At the time a team of glaziers were installing large glass windows against a backdrop of vivid January skies. 'I couldn't detect the glass so they looked like mime artists!' The glazier figures are being 'cross-fertilised' with influences from Renaissance and Baroque paintings and Jane draws every week at the National Gallery to study gestures and simply draw the figures. 'Beats any life drawing class that I've attended.'

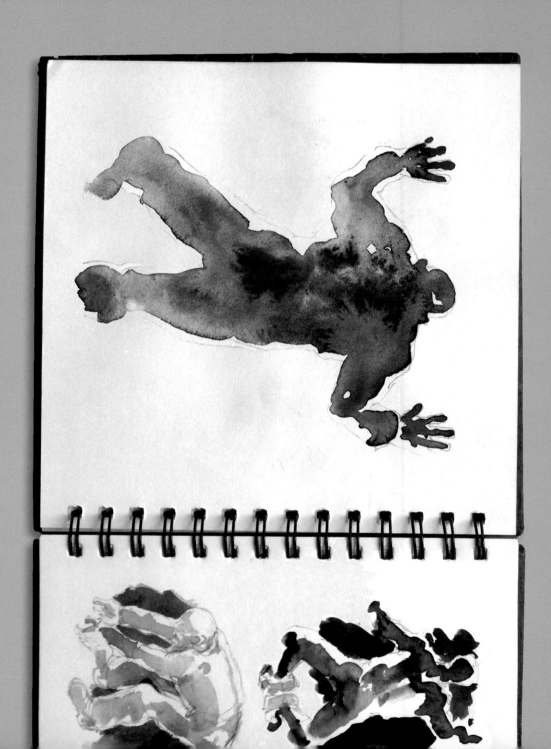

Access to some fascinating industrial locations have been made possible by seeking permission, which sometimes leads to an interview. 'At every place I have visited, I have been treated with great courtesy, a little curiosity at first, and then I just get on with the job of drawing. I try to tuck myself away somewhere as discreetly as possible, then I can observe and draw.'

Although usually private, Jane shows the odd sketchbook to students, to demonstrate how they can be used to develop concepts and plan ideas for future prints.

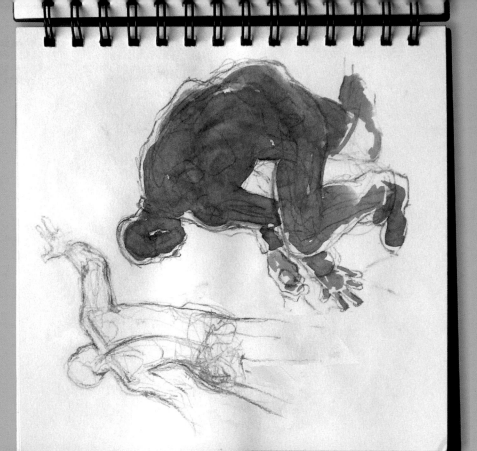

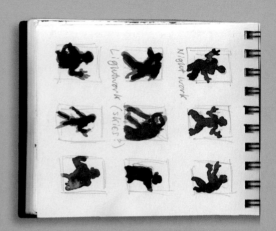

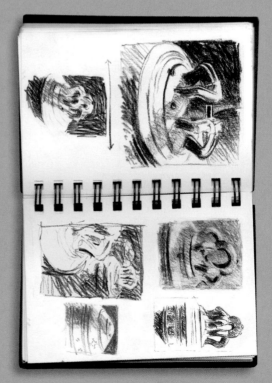

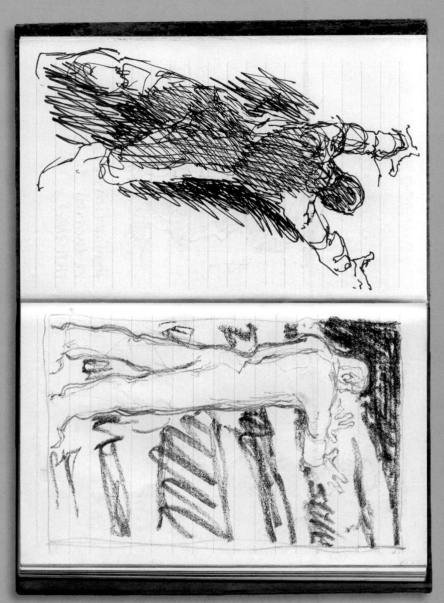

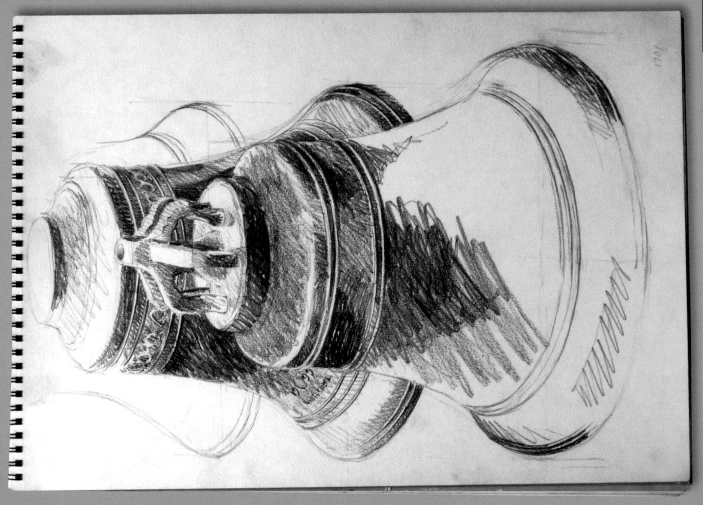

Julia **Rodrigues**

FINE ART PRINTMAKING GRADUATE JULIA RODRIGUES grew up in a small rural village in the North of Portugal where the connection with nature and the land were very strong. Planting and harvesting potatoes and corn were part of her family's annual agricultural tasks. Julia is therefore understandably in harmony with the natural world and is drawn to organic forms in her printmaking.

Over the three years of her degree course she has developed a conceptual and experimental approach using ideas that make reference to the patterns occurring in nature. Her sketchbooks have been the foundation for everything she has produced.

'I have a mixed-media approach in my sketchbook work and use it as a basis for experimentation and studies for current prints as well as for visual thoughts and ideas for further consideration. Collage and watercolour are my favourite media.' Julia also uses her books for drawn and written research. She has a preference for sketchbooks with good quality white paper, in a range of sizes.

Sketchbooks were a requirement of Julia's BA course, and formed part of her degree assessment. This was also the case at her secondary school in Portugal where they were encouraged and valued. Consequently, they are now a crucial part of her practice as an emerging artist-printmaker on an MA Printmaking course. 'Keeping a sketchbook has been very rewarding for my development and helps me with my conceptual and practical skills. I consider that some of my drawings/sketches have a better quality, expression and spontaneity than the final pieces of work. Sketchbooks are an essential element of my work.'

Julia's print work often forms part of three-dimensional structures, which her sketchbooks help her to realise. She greatly admires the printmaking of the Chapman brothers and Johnny Friedlander.

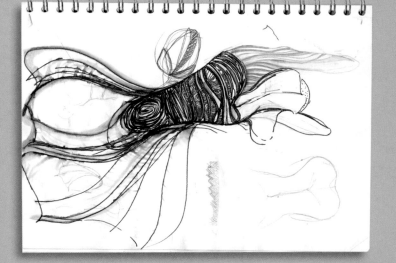

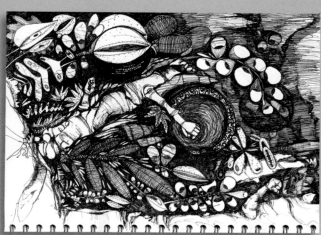

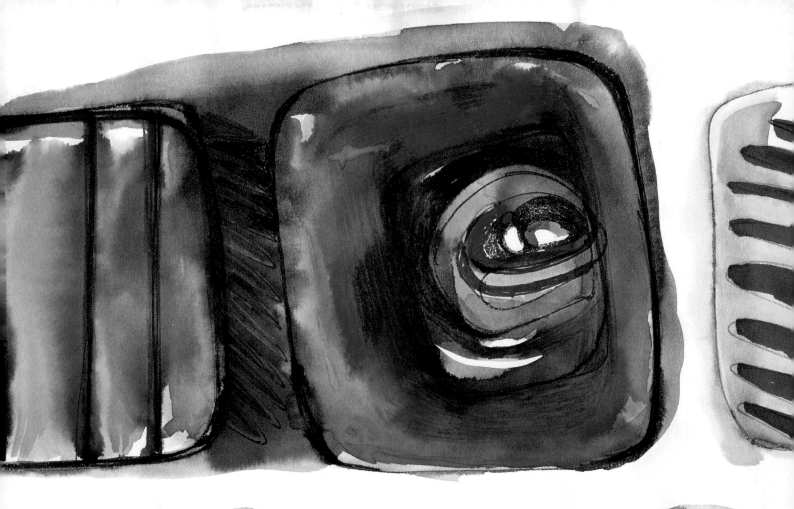

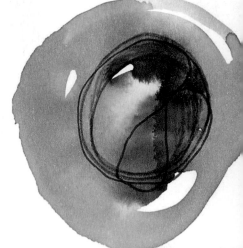

All of Julia's sketchbook images here found their way into her printmaking. References drawn from the natural world are enriched by the use of collage and strong colour.

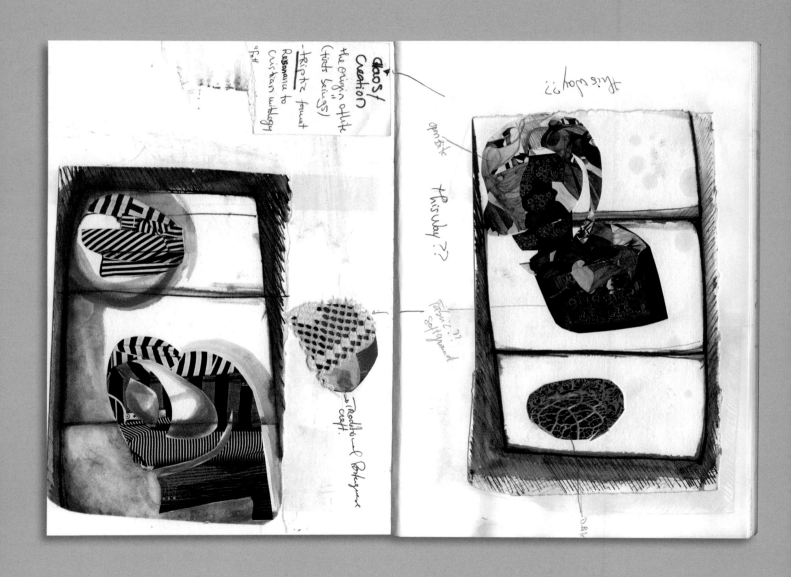

Chaos /
creation
the origin of life
("first beings")
-Triptic format
Resonance to
christian mythology
"felt"

this way ??

open Bite

this way ??

Fabric ??
soft ground

→ Traditional
Portuguese
craft

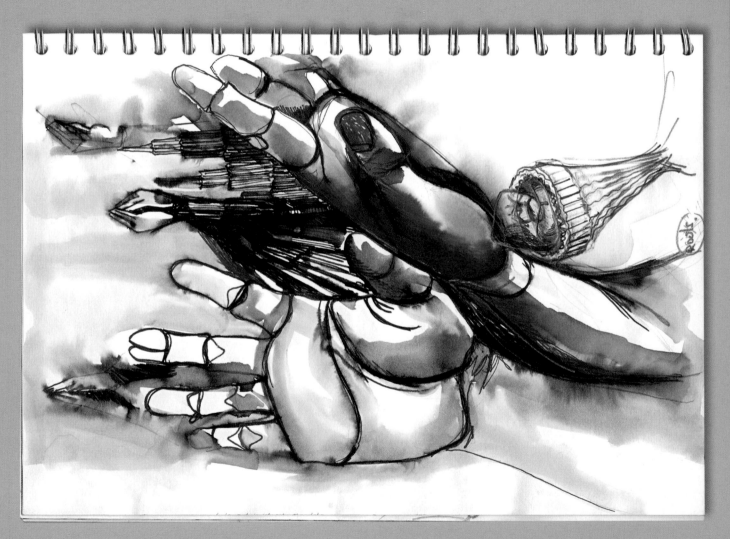

SCHOOL STUDENT JOE COURTLEY PRODUCED

Joe **Courtley**

exceptional sketchbooks as part of his coursework at school. He prefers A3 hardback books with heavy-weight paper because he likes to works with a variety of media and approaches. He uses his books for research and for the development of ideas for set and self set projects. The strain of fulfilling the academic demands of three 'A' levels is a challenge that would sometimes impact upon the upkeep of Joe's sketchbooks and when art deadlines were looming he felt under considerable pressure. However, he managed to set aside at least two dedicated periods of his busy week, just for this. 'Without sketchbook work the final piece usually turned out conceptually immature.'

Joe's final pieces of project work usually resulted in large paintings, carried out on canvas and board. They reflect the same exciting mixed-media approach prevalent on the pages of his sketchbooks. His final major project was an ambitious painting on the concept of meat, in all its forms. This work was later exhibited at the prestigious Mall Galleries, London, UK.

He likes the idea that a sketchbook can be a private dialogue between himself and his ideas, but obviously his teachers and the examiner scrutinized them at the conclusion of each project. 'I try to be methodical with the progression of concepts, so that the viewer can follow my development. A private sketchbook would appear fairly vague and disordered to anyone else but me. It helps to start out with as wide a range of ideas as possible, and to develop several of these throughout the book, rather than starting out with one definitive concept.' Joe's dedication to his art studies gained him an A-star grade.

Although Joe is now pursuing an academic degree course, he has taken his sketchbooks with him to the University, to record this new chapter of his life.

Joe's sketchbooks reflect his inventive approach to image-making and the broad range of connections he makes when developing his concepts.

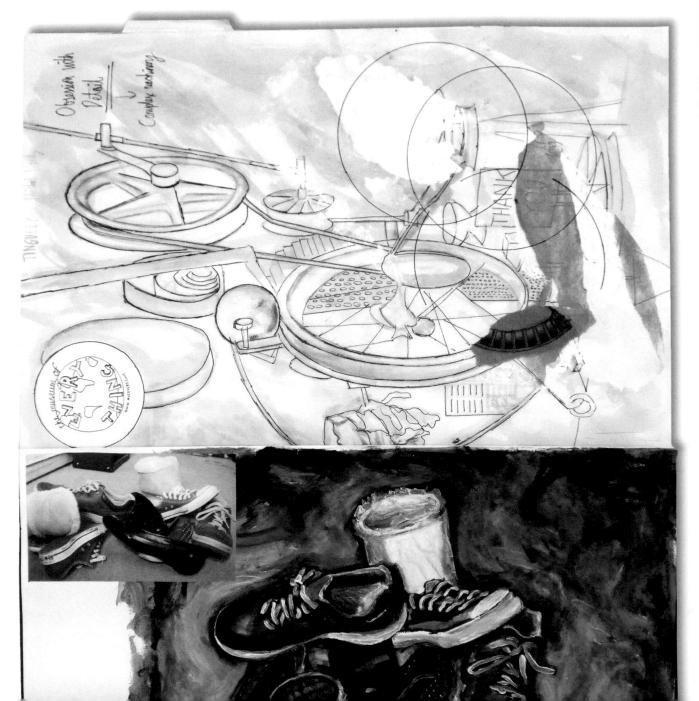

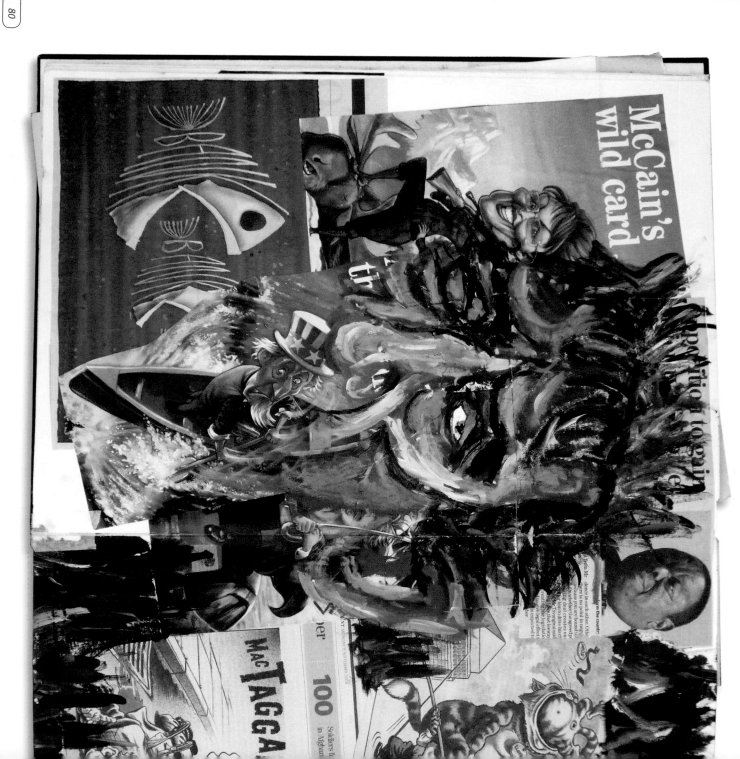

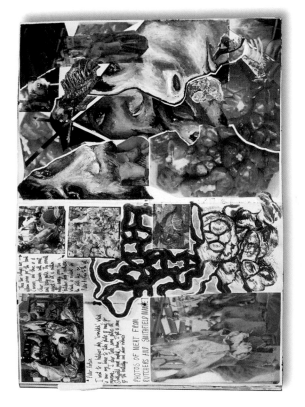

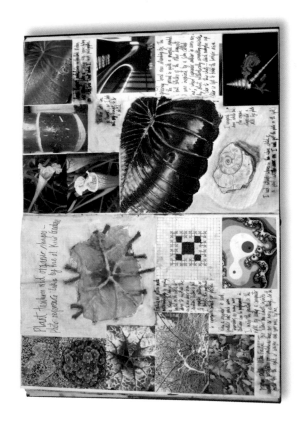

Judy **Groves**

ARTIST AND ILLUSTRATOR JUDY GROVES CAN'T IMAGINE

how she would plan a creative project without using a sketchbook. 'If I am preparing work for an exhibition of 25 or 30 paintings, I need to see them in miniature first – a very rough version. I also need to see them sequentially, to avoid a series becoming too repetitive.' The sketchbook pages included here are for a series of paintings concerned with religious iconography. 'It interested me that so little of the narrative need be present. The tilt of a head, the angle of a foot, a tiny part of a garment, were sufficient for the subject to be identifiable as a religious one. Also of course the colours and textures provided further information and clues.'

As an illustrator of many books, the 'design' of an image (painting or print) is incredibly important to Judy. However, when embarking upon commissioned book illustration she uses a different process for developing ideas, preferring big sheets of paper and a system of storyboards.

Judy is currently working on some large drawings featuring the figure, sometimes combined with monotypes. 'I would find it almost impossible to think clearly about a particular project without first working out each stage in a sketchbook and gathering together my research material.' However, her sketchbook drawing will remain just a sketch (or a written note) because she doesn't want the finished work to lack freshness by having ironed out all the problems and ideas beforehand. 'That would mean the conversation had already ended.'

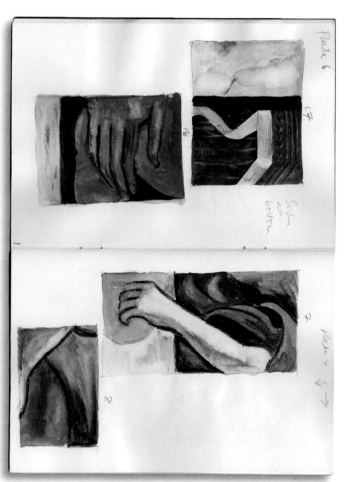

Examples from two of Judy's sketchbooks show drawings from her weekly life class, and design ideas for her *Iconography* series of paintings.

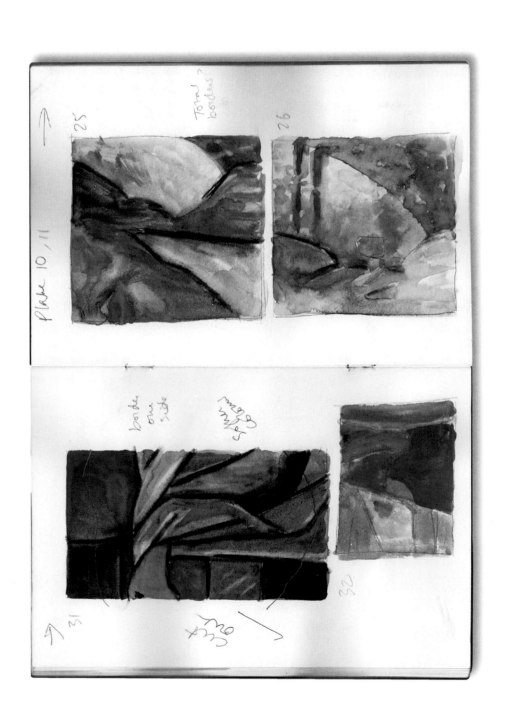

'I prefer thin sketchbooks with not many pages because each one will usually be on a single subject. I never use one smaller than A5 and rarely bigger than A3. They will normally be paperback without spiral binding. I often use a fountain pen or ballpoint, sometimes adding colour with water-soluble coloured pencils. But if the sketches are plans for a rather complicated series of paintings, which will be in colour, then I'll use watercolour or gouache to try different compositions.'

Judy's approach to image-making is figurative and as part of her artistic practice she draws from the human figure every week. For quick poses she uses an A4 sketchbook, which she finds economical and less inhibiting for experimental approaches to drawing. One of the sketchbooks included here depicts two very free drawings made while closely studying the model without ever looking at the paper as the drawing progressed. 'Because I do a lot of life drawing, the finished "unlooked at" sketch isn't usually very far out. In other words, I don't need to see what my hand is doing in order to draw it.'

Jackie **Newell**

SKETCHBOOKS PLAY AN ESSENTIAL ROLE IN THE WORK
of painter and printmaker Jackie Newell. She uses large books for drawing on location and a small one for recording ideas in written form. Back in her workshop, Jackie has a medium-sized sketchbook for experimenting with different media and effects. 'For research drawings I mainly use charcoal. I also enjoy using acrylic ink, applying it directly from the dropper, which can also be combined with charcoal. This creates an immediate response which keeps the idea fresh, both on the paper and also in my mind.' Sketchbooks play a major role for Jackie at the start of a project, as an initial source of inspiration before she takes the ideas further and into other media.

Jackie has always been interested in structures and constructions, particularly when they are in a state of flux or decay. 'I make drawings and notes on site and then take the visual research back to my workshop for further consideration and adaptation. My current theme is based on the Olympic site at Stratford in East London. I have made several visits, where I have spent days drawing from observation.' Jackie feels the need to have something tangible to base her work upon; in the original research drawings she attempts to capture the essence of the subject. She often wishes to extend these drawings beyond the actual format of an 'A' proportioned sketchbook and 'concertina' books allow her to create a seamless panarama without the need to tear out and stick the pages together. 'I like to work on paper that is sympathetic to charcoal and smudgy graphite and I prefer to work on a white or off-white paper, so I sometimes make my own version of the concertina books, using "Stonehenge" paper. This is a smooth paper, in neutral off-white shades, made in the USA.

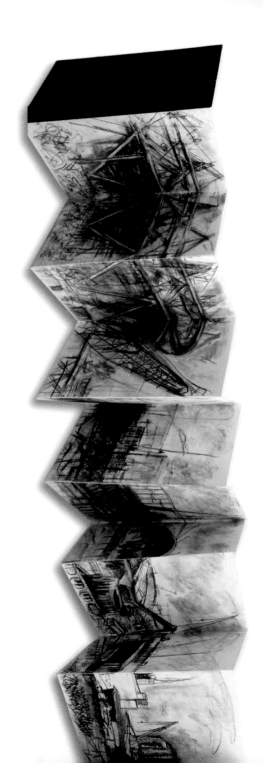

From her research drawings of the Olympic site, Jackie makes monoprints and mixed-media paintings. 'I find this wider approach to media necessitates a greater need for experimenting in sketchbooks, as was the case when I was an art student.' She admires and has been influenced by the work of many artists including Claus Oldenberg, Jim Dine, Giovanni Piranesi, Antonio Frasconi and the drawings of Walter Murch.

'When I'm drawing, I tend to be in my own world and oblivious to those around me. However, on one occasion, I was working on the floor in the corridor of the Victoria and Albert Museum in London, and I looked up to see that I was surrounded by Japanese tourists, snapping their cameras at me.'

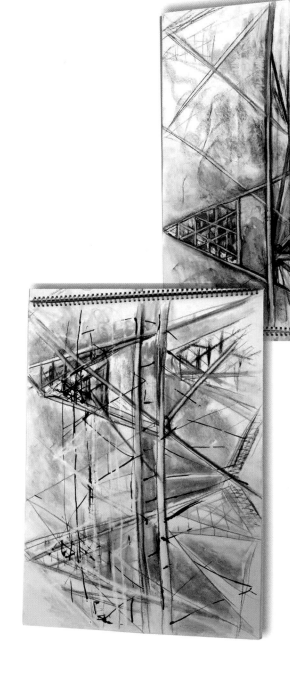

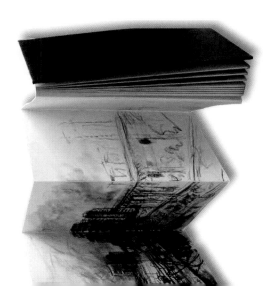

Jackie made regular visits to the site of the 2012 Olympic Games to record and respond to the activities and the emerging constructions as they changed the skyline of East London.

Nick **Clarke**

ART AND DESIGN COLLEGE STUDENT NICK CLARKE'S rather elegant sketchbook contains thorough and systematic experiments on metal. He takes his book everywhere, so it needs to be hard-back and sturdy enough to survive his daily commutes. Nick sticks his metal test plates directly onto the pages so favours a ring bound book, which will accommodate the inevitable thickening as the book grows.

Rusted leaves

'The theme of my current sketchbook is the exploration of light in a literal and non-literal sense. I am investigating the shiny, reflective qualities of different metals and how engraving, rusting and other ways of "distressing" can change the surface and its ability to reflect.' Nick intends to specialise in sculpture, with a particular leaning toward metalwork and he is currently learning how to weld. He is inspired by the work of inventive sculptors Andrew Chase and Kevin Stone, both of whom make large metal pieces on animal themes.

The thorough annotation in Nick's sketchbooks is a great help to him when developing further pieces of 3D work for projects and he often refers to the notes that document his findings. As his sketchbooks also play a major role in assessed coursework, it is also his intention to communicate clearly with the assessors at the end of each module.

'During my time at college I have explored a wide range of techniques and materials.' Consequently, Nick's sketchbooks are immensely useful to him, as an archive of his broadening knowledge and experience both as a practitioner and developing artist. 'I am currently working towards a metal, wall-sited sculpture which has been inspired by Ted Hughes' poem *The Iron Wolf*.'

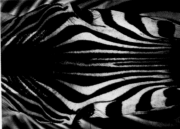

metal Bizmuth/Aztec designs

In Nick's current sketchbook he has been exploring ways of distressing the surface of metal to affect its ability to reflect light. These findings will influence a sculpture project that he is working towards.

Linda **Wu**

DOCTORATE FINE-ART STUDENT LINDA WU IS A PAINTER

who sometimes incorporates printmaking directly onto her canvasses. She uses sketchbooks, 'to record any ideas that come to me, before they disappear' and is often surprised to note that a subject or theme 'central in a series of paintings firstly appeared in her books many years before. Initially she found that keeping a sketchbook was quite alien to her. 'I did not want to expose my ideas and obsessions to criticism and would produce a sketchbook retrospectively, purely for assessment.'

'However, once I became more comfortable with the concept I regretted not having valued the process earlier.' Now she cannot imagine how she would expand her ideas without using a sketchbook. 'I started to make creative connections as I fed my thoughts into my sketchbook and the more comfortable I became with the process, the more glimpses of unconscious content would appear on the pages. I feel able to dismiss internal censorship when working in my books and have learnt to value everything that is in there.'

Birds are a recurrent symbol in Linda's work. 'My obsession with birds and the artefacts from Egyptian culture has been recorded in my sketchbook for several years and in one form or another, they are an important element in my paintings.' She is fascinated by crows; their grace set against their aggression relates to the issue of polarity, which is central to her work. ▷

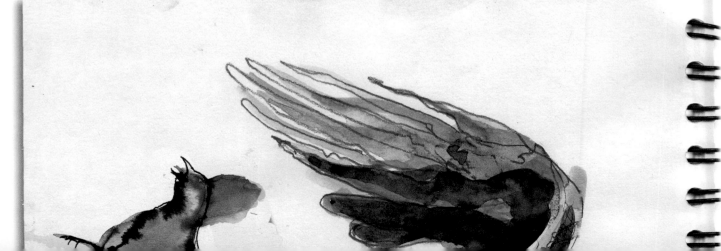

A murder of crows from Linda's studio sketchbook.
Birds are recurrent symbols in her paintings.

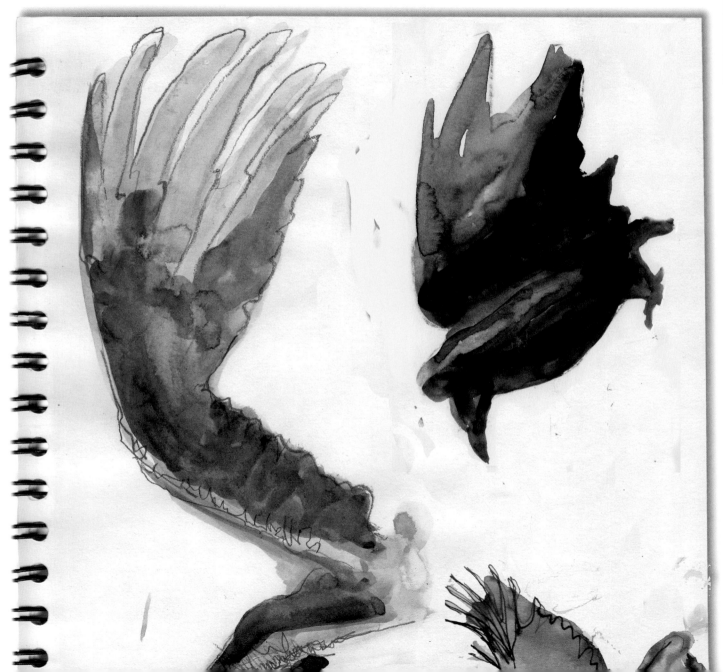

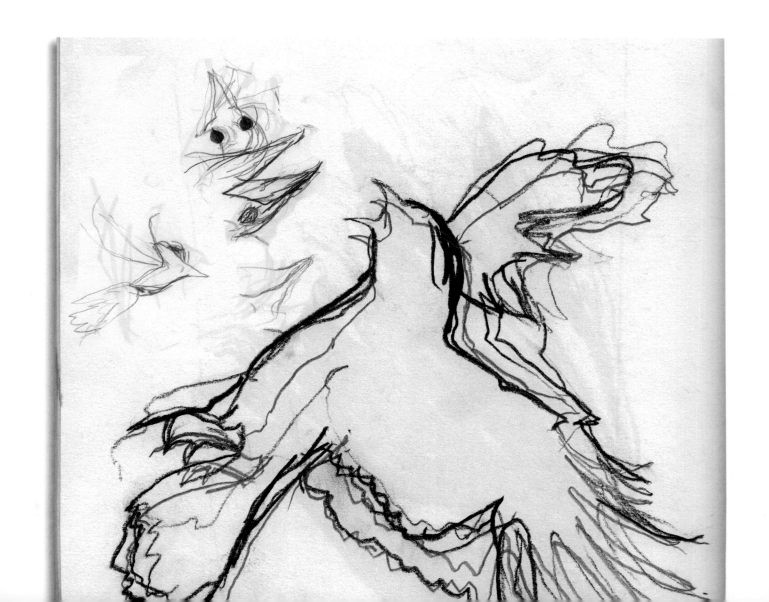

Linda has a mixed-media approach to image-making, using charcoal, pencil, paint, crayon, photographs, candle, ink and glue, and she scrapes into the drawings with a craft knife. 'I often reproduce photographs of images I want to use, then cut them out and move them around, as on a stage. I have one sketchbook that contains the ideas for most of my work and a second one that I take on holiday or use at life-drawing classes. The function of my second book is quite different to my main book; it is less reflective and less personal.'

Preferring to keep her 'visual thoughts' to herself, Linda is happier to use her 'ideas sketchbook' in the privacy of her studio. She considers that this book contains the very fabric of her personality and she does not concern herself with the quality of the drawings or how bizarre her ideas may appear, as she believes that they all have value. 'I regret that for many years I used odd bits of paper (now lost or destroyed) instead of a using a sketchbook as a reflective tool. I do not think I can express just how strongly a sketchbook has become an echo of my thought processes.'

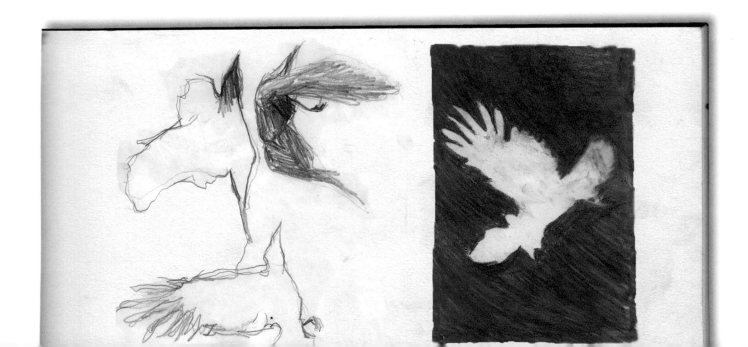

PAINTER AND WOOD ENGRAVER BLAIR HUGHES-STANTON

Blair **Hughes-Stanton**

1902-1981

made hundreds of life drawings as a student at the Royal Academy Schools and the Leon Underwood School, in the 1920s. He was not someone to always work in a sketchbook but often drew and painted straight on to good quality paper to create the finished image. Indeed by the time of his tenure (1930-1933) as Artist in Residence at the Gregynog Press he was known to create his elaborate wood-engravings from the 'merest scribble on the surface of the blackened block.'

However, when he did use a sketchbook it seems to have been employed for various reasons. In the main the images consist of compositions from his imagination for further paintings and prints. There are also phrenetic drawings in pencil as an exercise in loosening up. His 'idea drawings' for the semi-abstract paintings from the 1930s were often drawn on to random pieces of paper and then squared up very accurately for the paintings. This method was also used in the early 1950s for his *Homeric Watercolours*, elaborate ink and watercolour pictures inspired by Greek myths and *The Iliad*.

The sketchbook drawings depicted here come from a French sketchbook with pages 16 x 21 inches. He wrote on the first page '16x21, 15x20, 3x4' so, fresh from Gregynog, he was still thinking in proportions, as for books. The tiny minimal drawing of two figures in the first image is redrawn more decisively in the larger version above. Inset into images one and two are the colour wood engravings that evolved from these designs. The evidence of sticky tape on some of the pages suggests tracing paper was used to transfer the images onto blocks of long-grain pear wood, one block for each colour. The prints are dated 1935, so the drawings would be that date also as they are a deliberate start to the prints rather than completed drawings in themselves. ▷

Images 1 to 4 reveal Blair Hughes-Stanton's preparatory drawings for further work. The inset colour wood engravings in 1 and 2 show the finished prints. The final sketchbook page is one of many life drawings made by the artist; the model here is thought to be his wife.

1

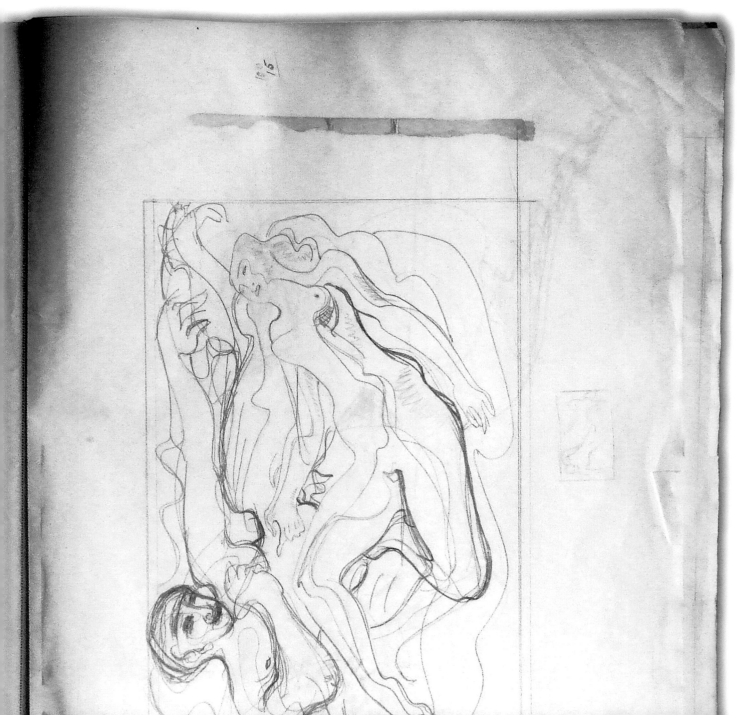

2

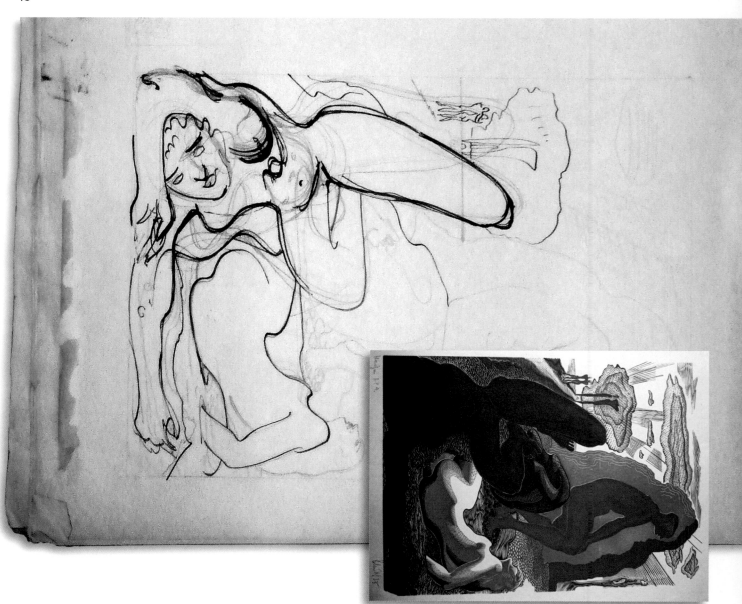

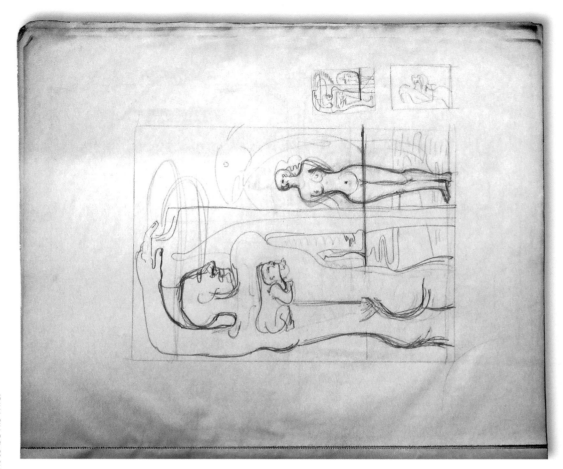

Generally, Blair seems to have torn sheets out of his sketchbook to make drawings and pinned them to a board. He often worked in pencil, pen or even biro, as well as drawing directly with watercolour paint. Image no.5 is from a Windsor and Newton 'Rathbone' Sketchbook (22.9 x14 cm), which is full of life drawings, some possibly from his classes. The model is thought to be his wife.

3

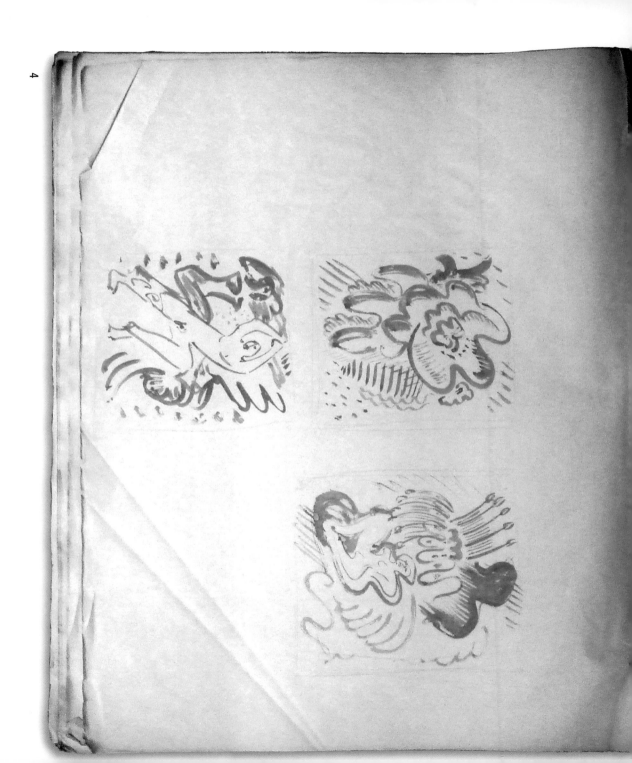

4

Thanks to Penny Hughes-Stanton for her assistance with this profile.

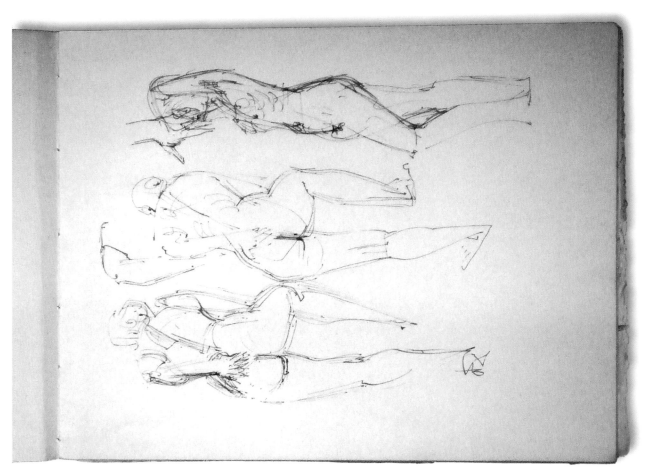

Giovana Picone

COLLEGE STUDENT GIOVANA PICONE HAS PRODUCED two sketchbooks this academic year on the themes of 'stacked' and 'dystopia' (an imaginary place where everything is as bad as it can be). From these starting points, she has been encouraged to interpret and develop original concepts through the creation of exciting sketchbooks, leading to final pieces of work. Her coursework is assessed at school by her teachers and moderated by the exam board, towards her final grade.

For Giovana, the Swiss surrealist H. R. Giger, has been a major influence. 'His work is so dark and unnatural and fits in with the whole concept for dystopia. The image of the skull was dominant in my project and I studied a few artists who had used this image in their work. I always use two sketchbooks; one is full of art history research and life drawings and another is for ideas that are expressed in mixed-media techniques. I adore drawing in biro, which makes an observational drawing so much more fascinating; I like the biro to "stress out" onto the page. I can never just work with one media, I always add more: cut into it, rib it and draw onto it, sew into it.'

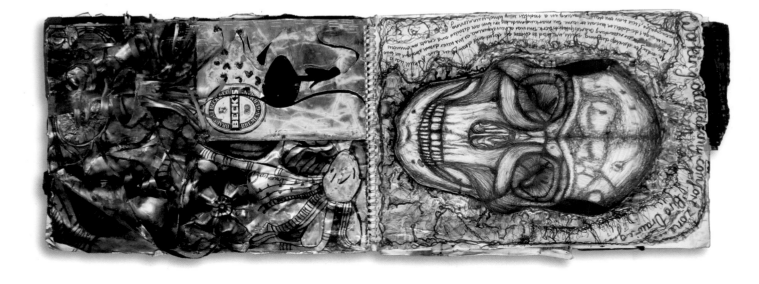

Because of the very physical way in which she works, Giovana needs to have thick paper in her large sketchbooks as a base for her multilayered working methods. She starts by using scraps of newspapers, card, etc., onto which she applies washes of colour. 'My sketchbooks are very personal, like a diary, and they allow the work to have some authenticity, as the paint and ink leak onto the next page. My work is very disordered but I think that's acceptable in a sketchbook.'

'At home I use my sketchbook on the floor in my bedroom, surrounded with materials, paints, inks and with my music full blast, which really adds to the personal aspect of my work.' Although the purpose of her sketchbook is coursework for her final examination, Giovana feels it to be her main creative vehicle. 'It is a pleasure to keep a sketchbook, although always an emotional experience, as it will be graded. It's essential to me to have this very personal dialogue, as well as being valuable *en route* to my final pieces of work.'

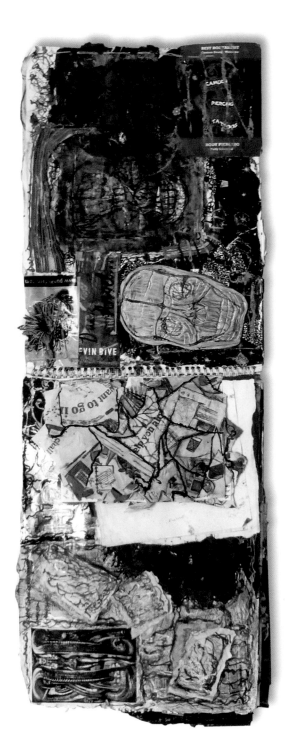

Giovana's sketchbooks develop ideas and set a mood for the theme of 'dystopia' (an imaginary place where everything is as bad as it can be) using inventive approaches with mixed media.

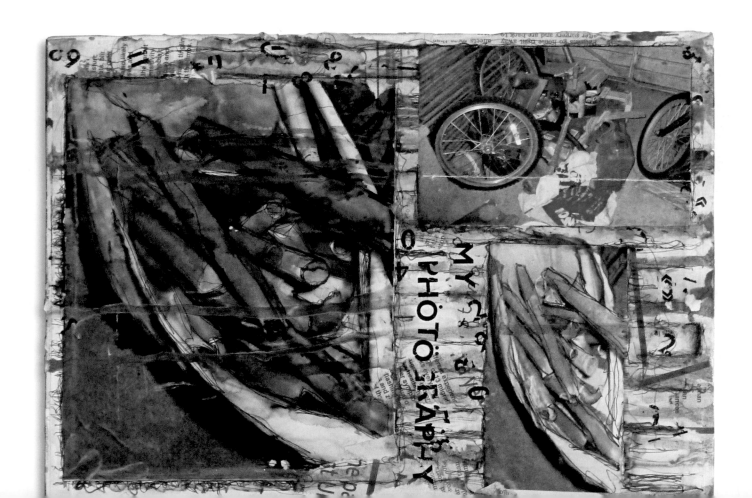

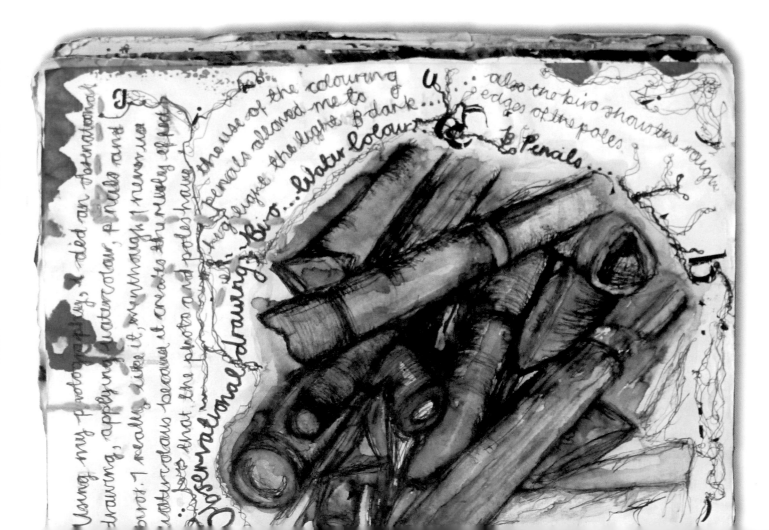

Sheila **Graber**

ANIMATOR AND FILM-MAKER SHEILA GRABER NEVER GOES
out without an A5 sketchbook, usually spiral-bound. She uses it on
the train, the bus, on holiday and in hotel rooms where she has time
to think. 'If I'm planning a movie, being on the train is great; there
are no interruptions from phones or doorbells and I can just let my
mind roll on.' She also likes to record where she is at that moment,
or whom she is with. 'I find I remember a place much better if I drew
or painted it, than if I just took photos.' Sheila is currently working in
two sketchbooks.

'As a student (1958–60) we had to keep sketchbooks – I still have
most of them and I guess this got me into the habit that has lasted
50 years (and will hopefully continue for more). Come to think of
it I did make little drawings and stuff at home before art school, so
maybe I've always felt a need to record visually what's going on in
my life. I just wish now I'd dated
everything and written down
where I was at the time. I have
dated my books since 1996 when I
started travelling the world again.
I wish I'd done it much earlier.'

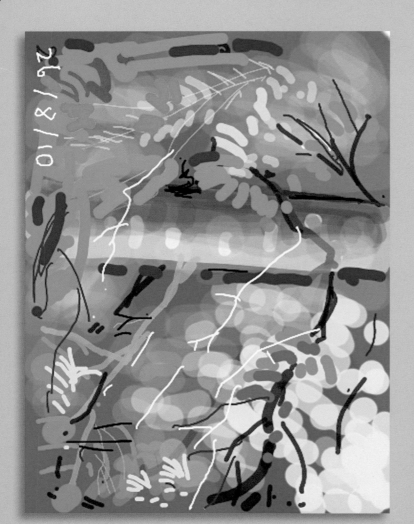

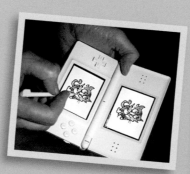

Sheila documented a return
journey between Southern Ireland
and South Shields, using her Nintendo
'sketchbook'. Following this are selected
spreads from small travel sketchbooks;
the page entitled 'lifeline' sketched on a
plane journey to Paris shows her very first
'storyboard' for what would become an
award-winning animation. She reckoned
the aerial view of our planet put the idea
she'd been considering for 15 years into
clear perspective and she was at last able to
jot it down in one go.

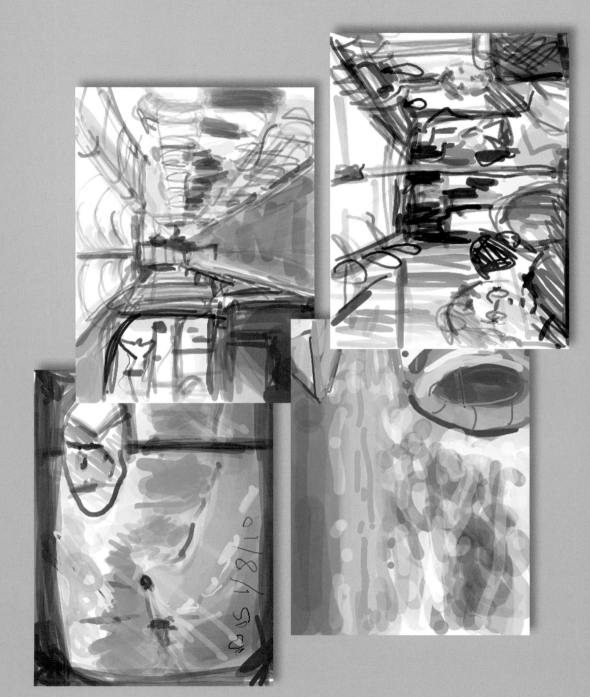

Sheila also uses her sketchbook for making technical notes about music and camera software etc. Her sketchbook is where everything starts, and then comes together. 'I suppose its main purpose is to clarify my thoughts. I feel it's of no value to anyone else, as others will hopefully see the end product rather than the journey.' ▷

Currently, Sheila is working on an idea called 'Quizi-Cat's Quest', a mutli-media concept to help junior school children be creative and cross-curricula with a cat as the key character. 'I'm starting to use a sketching program on my Nintendo 'Art Academy' as well as my usual spiral-bound paper job. So I guess my own working practice is changing with the evolution of new gadgets.'

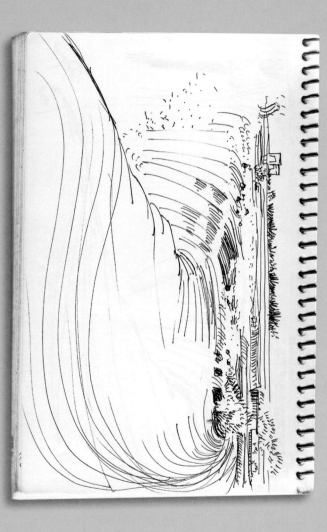

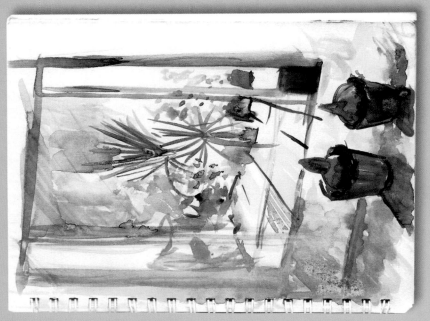

Through her friend Nerys Johnson, who was curator at the Durham Light Infantry Museum, Sheila gained access to some 'behind the scenes' glimpses of the sketchy thought processes behind the work of the world-class artists featured at the Museum, such as Picasso, Lottie Reiniger and Henry Moore. 'It helped me realise that most great ideas begin small and sketchy.'

Sheila thinks about her sketchbook as an extension of herself and a constant friend. When she's drawing in a public place, a comment that people often make is: 'I can't even draw a straight line' – to which she answers: 'Well, do you need to? Wobbly ones are so much more interesting...'

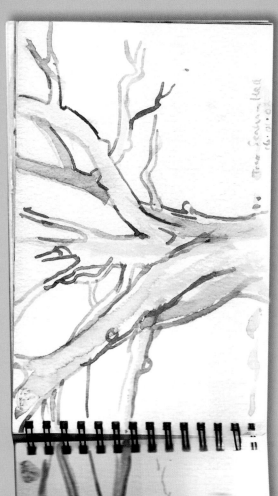

Mustafa **Sidki**

GRAPHIC DESIGN LECTURER MUSTAFA SIDKI WORKED AS
a 3D designer of children's novelty books, and he now runs a
graphic design course in a college. In his spare time, one of his
passions is printmaking. His specialist expertise led him to
experiment with interesting low relief ideas that are resulting in an
unusual sketchbook. Mustafa was brought up in a devout Muslim
household and his work is concerned with looking back to things
that once formed a large part of his daily life.

Islamic prayers feature in many of his images. In some of the prints
he uses wooden type and casts it in various materials, often
containing photocopied images which form a montage. All of his
tests find their way into his sketchbook prior to commencing the
final pieces. 'Prayers featured in every activity, such as eating,
sleeping, sneezing, leaving the house or doing anything important,
such as school examinations. Everyone in my household would fast
for the month of Ramadan and have their hands hennaed in the
traditional way.'This experience is proving to be a rich source of
inspiration for Mustafa. ▷

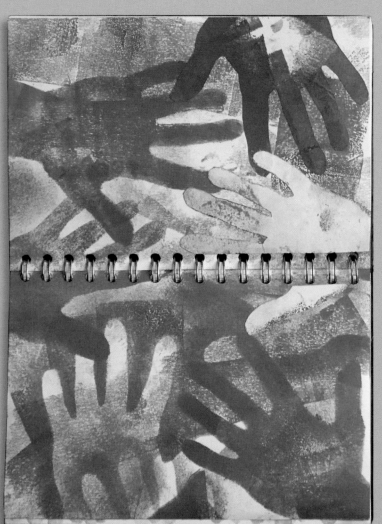

This printmaking sketchbook
is inspired by Mustafa's memories
of his devout Muslim upbringing.
It is an ongoing record of his ideas
and tests, prior to the creation of
large-scale prints.

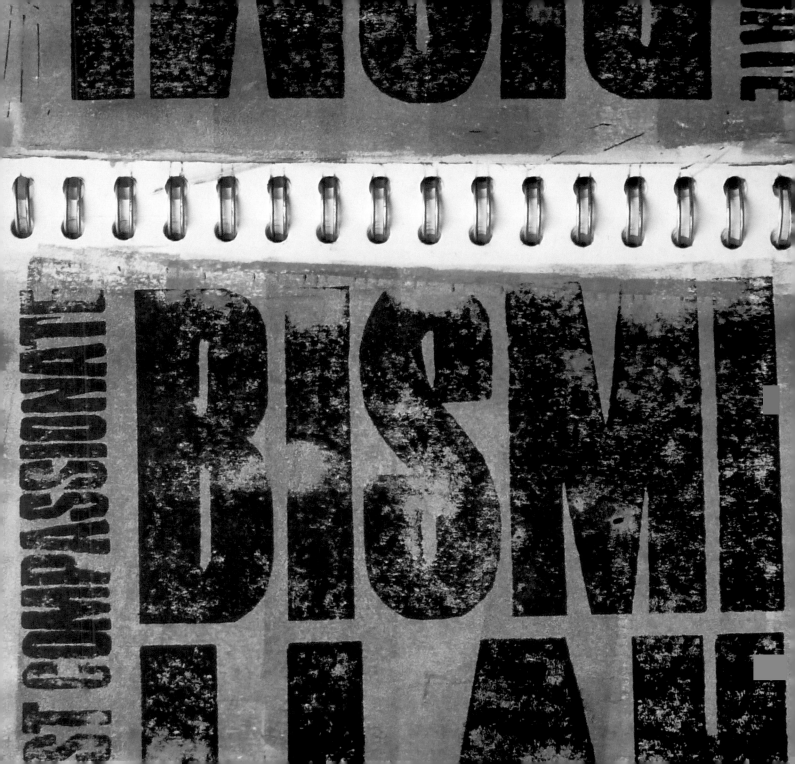

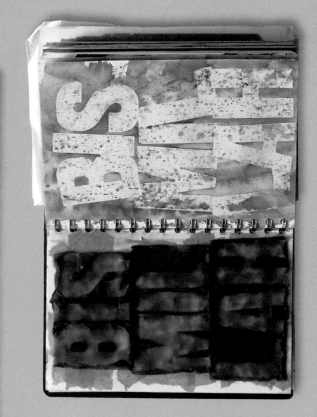

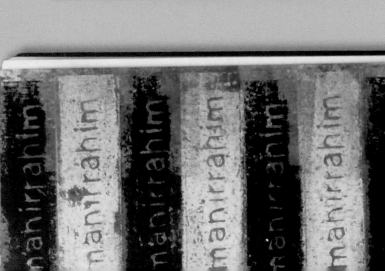

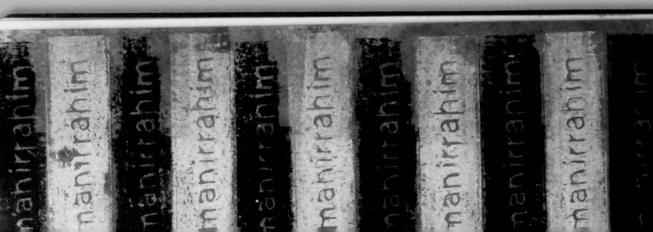

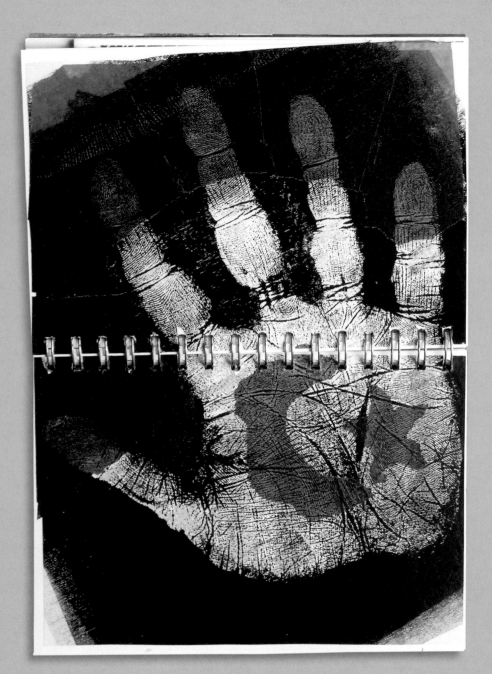

Because of his experience in the graphics industry and the subject of his teaching, Mustafa has a love of typography which features in many of his ideas. On some of his sketchbook pages wooden type has been printed directly, using oil-based ink, then he washes over it with water colour paint. When he produces digital images, he prints them out at a reduced size and sticks them into his sketchbook to keep a complete record of the entire progress of his ideas as they develop.

The sketchbook that Mustafa is using to document his prints has a large-gauge spiral binding, enabling him to open the book wide and keep the pages flat against a table, which is essential for printing by hand. The addition of the low-relief pieces is resulting in a fat book, which the binding can accommodate. "To keep a record of all my print work in one sketchbook appeals to my methodical nature, but I also feel that I am creating a type of artist's book, which relates back to my many years of working with a variety of children's book publishers, where I was employed to "engineer" all manner of whacky book prototypes." The idea of creating a limited-edition artist's book is a possibility that Mustafa is now considering, having been inspired by the way that his sketchbook is developing.

AL-HAMDU LILLAH RABBIL ALAMIN

ALL PRAISES AND THANKS BE TO ALLAH, THE LORD OF MANKIND AND ALL THAT EXISTS

BISMI LLAH AR RAHMAN AR raheem

IN THE NAME OF GOD, MOST GRACIOUS, MOST COMPASSIONATE

Madeline **Fenton**

FINE ARTIST MADELINE FENTON IS EXTREMELY INTERESTED
in the craft aspect of the work that she creates. It is no surprise then
that she prefers to make her own small sketchbooks 'The process
of making a sketchbook from scratch, using interesting paper or
fabrics or coloured paper, all add to the magic for me.' She uses
sketchbooks for drawing in museums and to document experiences
that will jog her memory for future artwork.

Madeline started keeping a sketchbook years ago when she went
on tour with an orchestra to Tuscany. 'All my professional life I was
a cellist and toured a lot in the United States, Europe, Australia and
South America. I liked using a sketchbook to make visual notes of
things, and events that I wanted to remember; I found it was much
more meaningful for me than taking photographs, and, of course it
improves my drawing skills. I try and complete a day a page.' On one
trip abroad Madeline carved into her erasers making simple shapes
of palm trees, churches and vultures, which she pressed onto an ink
pad and then printed into her sketch book. 'They work well when
they are repeated.'

'When I visited Guatemala I loved the women's clothes in particular,
the colours they use are so vibrant. I bought some antique textiles
and threads in the market in La Paz and when I came home I used
them for a series of embroideries, using my sketchbook drawings.
I painted the calico cloth and machine-embroidered the images
using the thread like ink from a pen; I also added some stump-work,
which is a 17th-century three-dimensional technique.' ▷

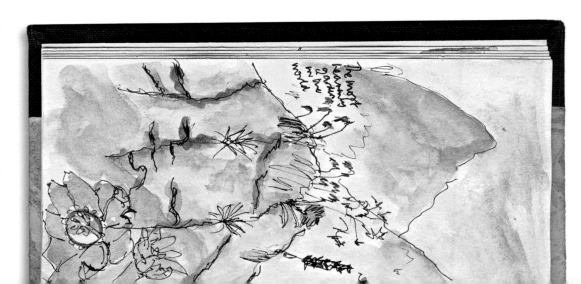

The examples here are from some of Madeline's
travel sketchbooks depicting scenes of Ecuador, Las Vegas
and Guatemala.

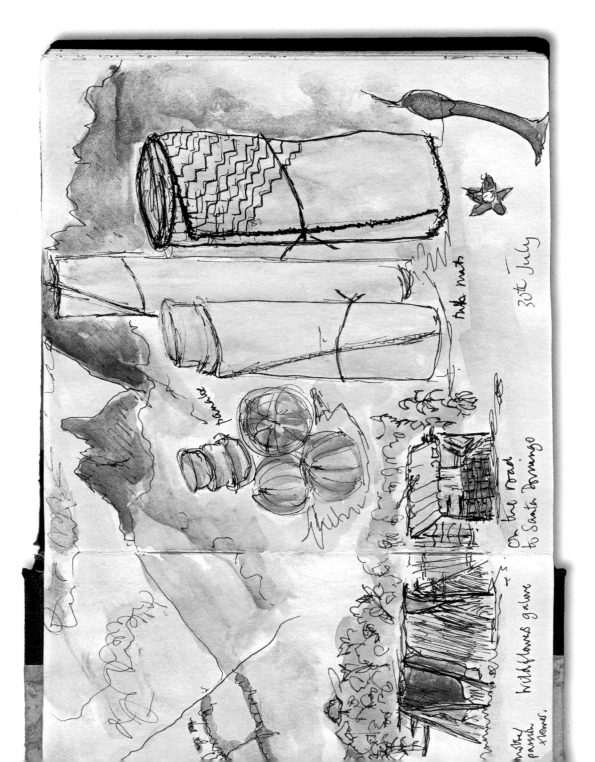

tuka nuts

30th July

On the road
to Santa Domingo

wildflowers galore

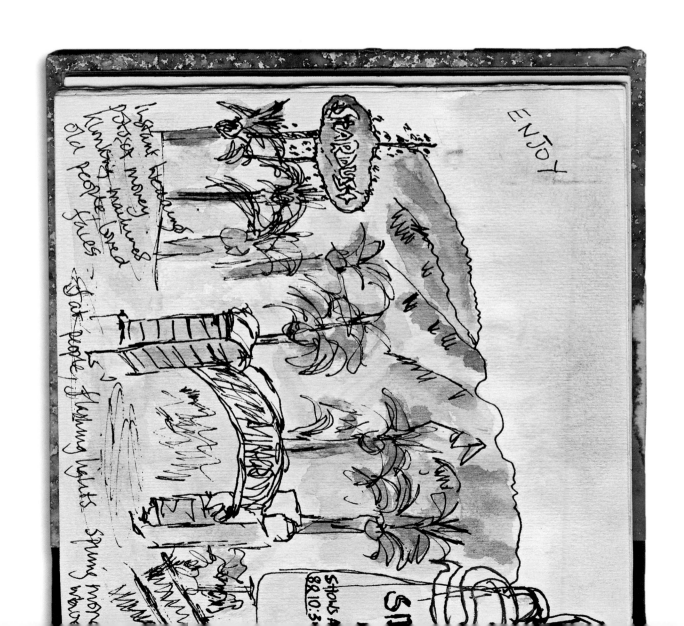

ENJOY

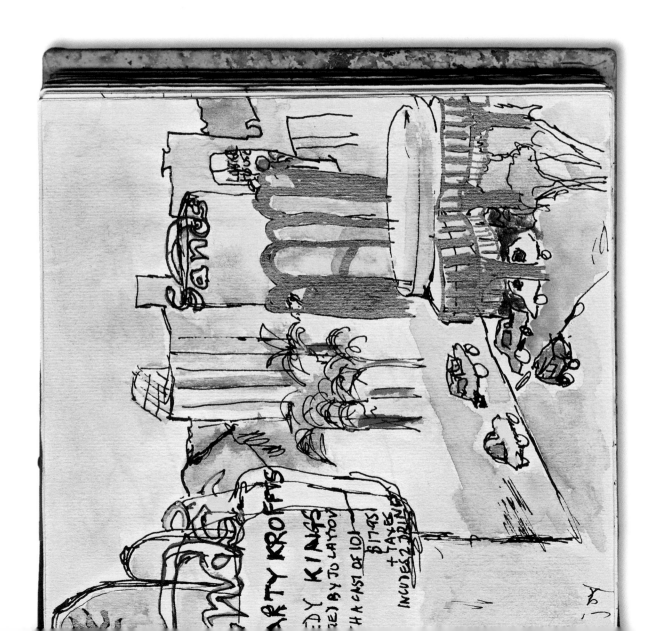

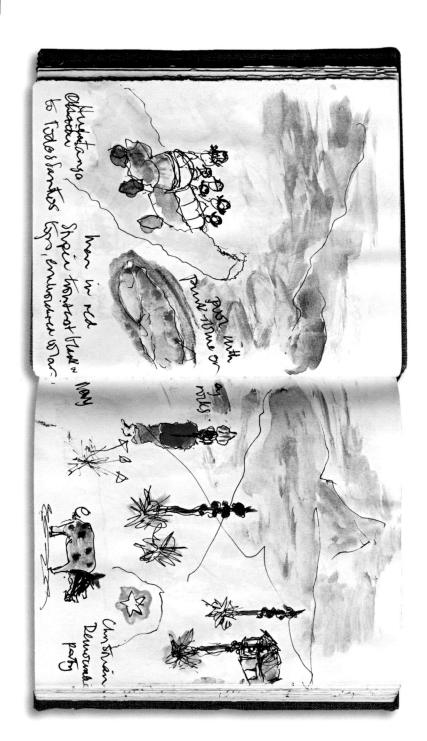

'Sometimes I won't let a day go by without doing something in a sketchbook, and at other times I don't use one for months.' Although Madeline's use of her books is sporadic, she never travels without one and due to her intense periods of activity, she has accumulated many. She is influenced by the work and also the methods of the Old Masters and is trained in the painting techniques of the 15th and 16th centuries, grinding the pigments and making the gesso for the small panels that she paints on. When researching for a new body of paintings, Madeline's sketchbooks are a vital tool.

She makes extensive experiments, mixing colours and writing notes describing how she arrives at various degrees of saturation and de-saturation. Hans Holbein and Hans Memling are two of the artists that Madeline will look to for inspiration.

When drawing in a market in China some years ago, Madeline became an object of huge interest and attracted a large crowd. Those particular drawings evoke fond memories of time and place.

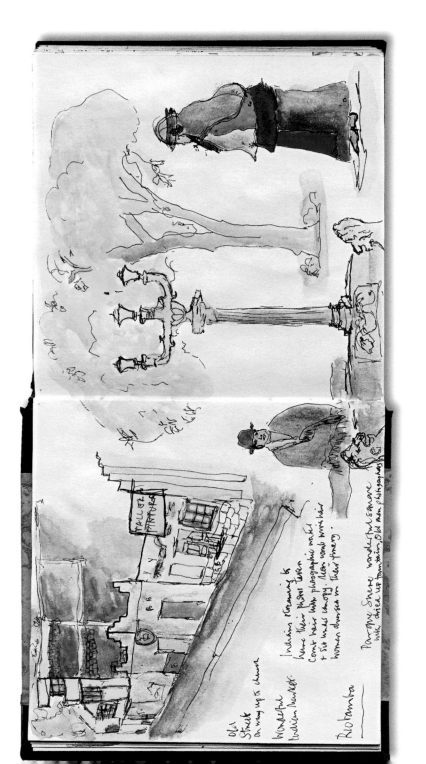

Old
Street
on way up to church

Wonderful
Indian market.

Riobamba

Indians streaming to
have their hair plaited here
comb hair into photographic mats
+ Sit most among. Also comb mini-hair
women drowsen in their finery.

Panagua Shrine wonderful scream
with dried up tomatoes Old men photographing

Harry Eccleston OBE

1923-2010

HARRY ECCLESTON WAS THE FIRST IN-HOUSE DESIGNER
at the Bank of England and creator of the 'D' series of bank notes, which came into circulation from 1970 in the UK. For this great achievement he was appointed the OBE in 1979. Harry was President of the Royal Society of Painter-Printmakers from 1975 until 1989. Despite his incredibly busy and demanding life, he continued to teach an inspiring printmaking evening class which influenced and encouraged many young people. His work as an artist was never compromised and he continued to create wonderful aquatints and watercolours.

It was Harry's practice to carry a small sketchbook wherever he went. He drew people in cafes, in train stations, on beaches or anywhere he could study the overall shape that a group of people made, and the interaction of shapes within the group. All of the observations that he made through his dedication to drawing fed into his creative work. Harry thought that his interest in shape probably went right back to growing up in the industrial Black Country (UK) where, as a young boy, he could see the strong silhouette of the Bilton Steelworks from his bedroom window. Industrial contours against the sky were certainly a recurrent theme in Harry's work, having been brought up in a place where he always had to look up to see the horizon, surrounded as he was by embankments. ▷

The examples of Harry's sketchbooks shown here, are from the 1940s and 1950s during his time in the Royal Navy in WWII and afterwards, as a mature student at the Royal College of Art in London.

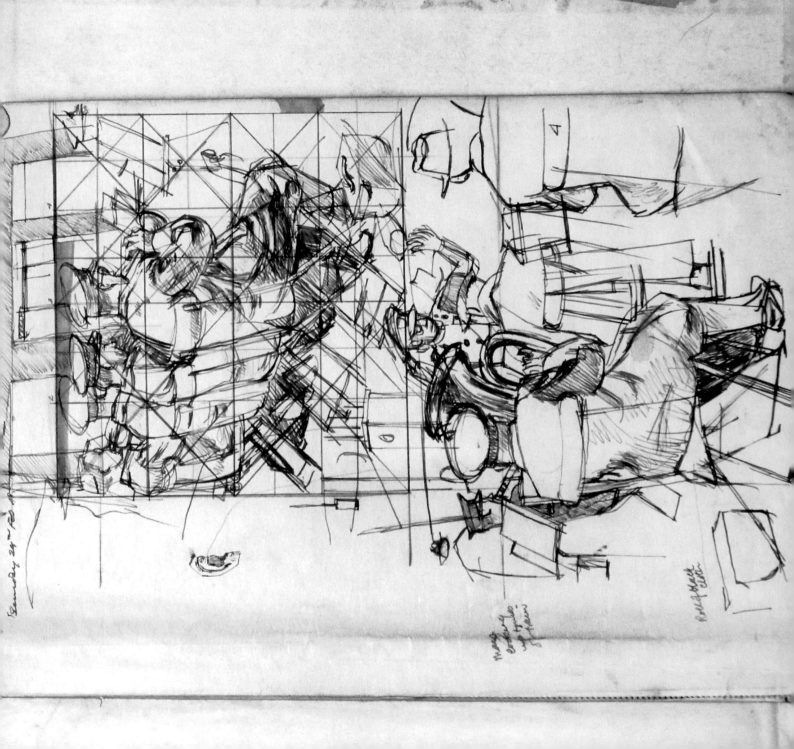

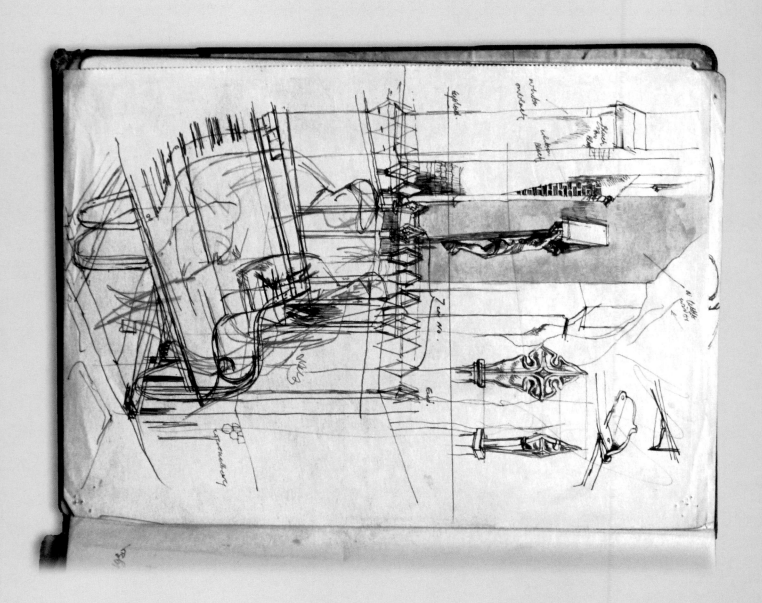

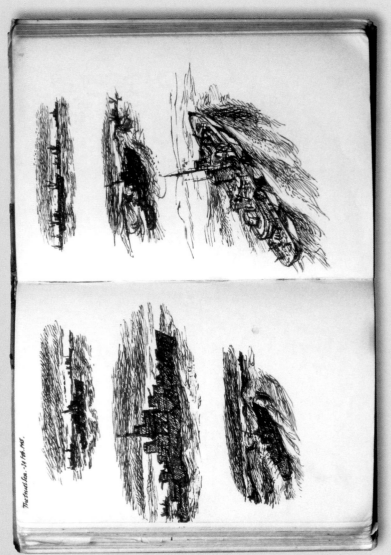

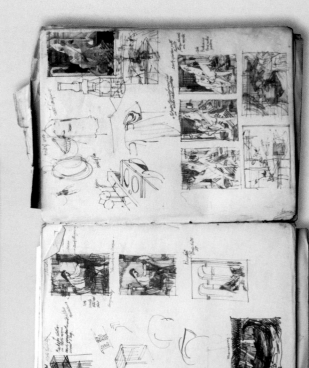

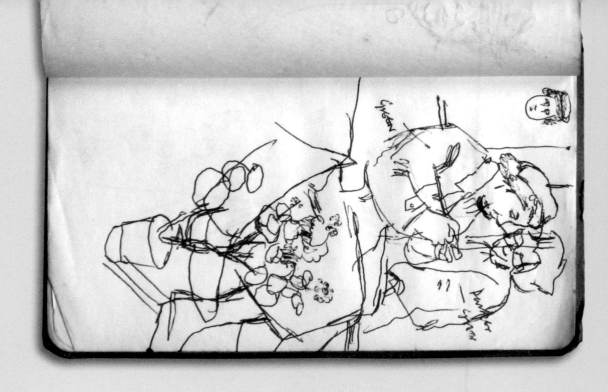

Harry believed that drawing was essential practice for all visual artists and designers and encouraged his students to carry a sketchbook with them at all times. A particular focus in several of his small sketchbooks was the study of the way that people's clothes folded and creased, responding to the structure of their bodies. Harry believed that drawings would usually reveal that you are either 'a line person or a shape person'. It was an interesting observation and in my experience of teaching, this does tend to be the case.

Harry's daughter Jennie kindly offered me access to twelve of her father's sketchbooks spanning the 1940s and '50s, and I have included a selection of examples here. They cover the period of his life in the Royal Navy during WWII and the post-war years when he became a student at the Royal College of Art in London. Judging by the breadth of subject matter, it seems that Harry was very comfortable when working in his sketchbooks and they were clearly important to him and to his work as an artist. Some of his later sketchbooks are held in the collection of the Birmingham Museum and Art Gallery (UK), along with many of his prints and paintings.

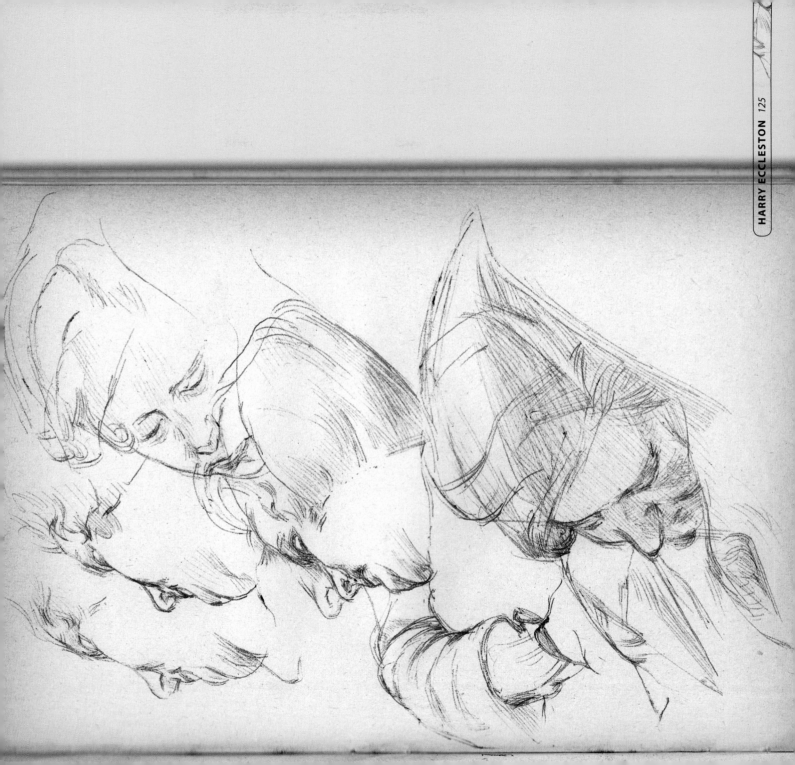

Alice Courtley

SCHOOL STUDENT ALICE COURTLEY USES A SEPARATE
sketchbook for each art project she carries out at school. An examiner assesses this aspect of her coursework, in order to ascertain the breadth and thoroughness of her creative journey towards each final piece of work. She favours large sketchbooks with good-quality watercolour paper that will accommodate water-based paints and mixed media. 'If I want a coloured paper, I just wash the page with watercolour and draw on top of it.' Alice tries to work in her sketchbook every day, or on additional pieces of paper, which she sticks into her book. 'I normally use my sketchbook on the dining table, so I can spread out all my work.'

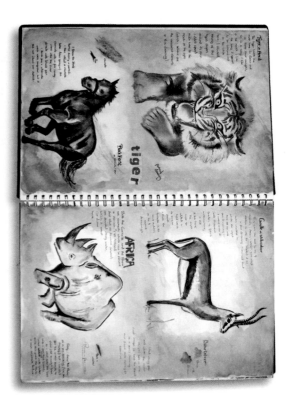

Alice's most recent sketchbook was for a project entitled *My World* and it focused on music, which is an important part of her life. Her grandmother is a well-known jazz musician and Alice plays the saxophone. This book contains a broad range of work, including observational drawings and photography. She uses the internet

for much of her research, but also visits galleries when she can. On high-school courses, students are encouraged to use a wide variety of approaches to image making and media, and are expected to annotate each stage of development. With a heavy academic workload from her other studies, it was sometimes a struggle for Alice to give her sketchbooks the attention they require, but somehow she managed to make a contribution on most days. 'I put a lot of effort into making my sketchbook visually exciting so that other people can look at my work and understand more about it.'

The art students at Alice's school were made well aware of the implication of a good sketchbook on their final grades. Alice's efforts did pay off and she recently received a top grade for Art. With further Art studies to follow, she feels that sketchbooks are a way of life for her now and recognises that they are an essential means of developing her ideas. 'They are the perfect vehicle for bringing together a variety of notes and images, both made and found.' The encouragement given at school to use a sketchbook for the documentation of broad research, ideas and annotation is an excellent way to enrich a creative solution.

Alice's sketchbook examples depict some of her developmental work for various school projects. This coursework is a requirement of her art examination.

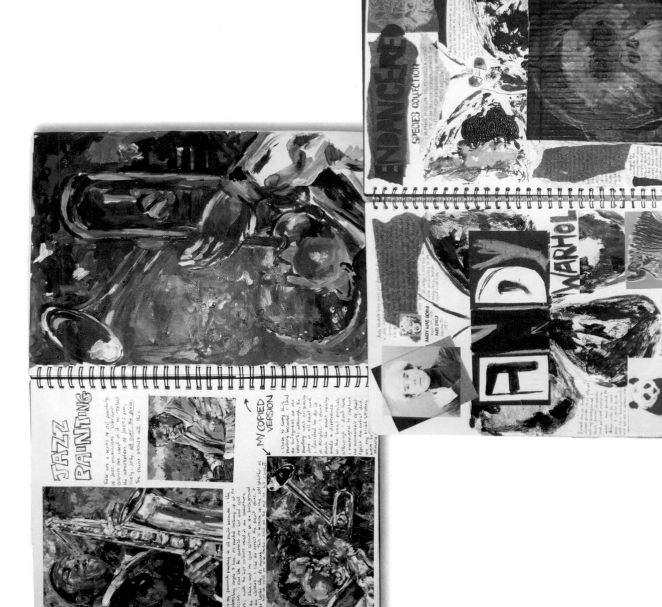

Anne **Daniels**

FINE ART DOCTORATE STUDENT ANNE DANIELS

specialises in printmaking. Her work is experimental, rich and interesting. She draws her ideas from many sources, such as mathematics, Chinese art and marks in nature. She uses her sketchbooks as a working document of ideas both visual and theoretical, and for her current art research. 'Anything tangentially connected, interesting or beautiful, a record of my creative life. I seem to have periods when I generate ideas for work much faster than I can use them for prints. Then when I am stuck, I re-read my sketchbooks.'

Anne uses her books at home in the evening to enter written material or to collage photographic images. In her college print-room she refers to them as she works. Her sketchbooks do not form part of her assessment but are a vital to her development on this demanding course of study, especially to generate her ideas and keep together all of her thoughts, both conceptual and visual.

Anne keeps one sketchbook specifically for making drawings and notes at exhibitions. She collects material pertaining to her current research project and writes in items of interest towards future investigation. 'At any one time, at least one artist will be influencing my artwork. I'm a great fan of McKeever, Virtue, Tyson, Muafangejo and Pollock.'

These sketchbooks of Anne's from her Fine Art Doctorate course show images of landscapes where she uses colour to draw attention to global erosion.

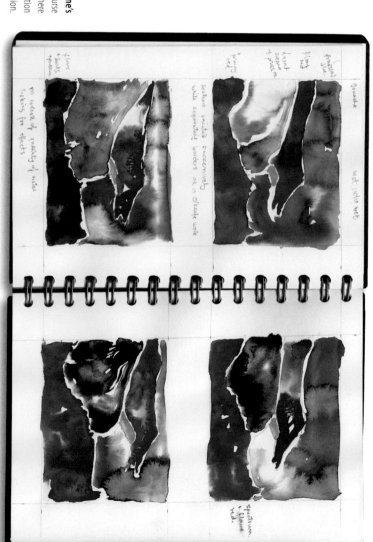

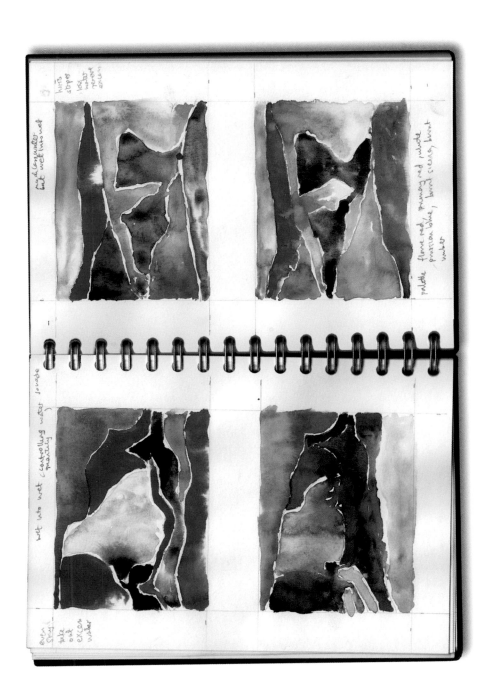

'My approach to my studio sketchbook is definitely mixed media. When drawing from life I might use any soft drawing pencil, black drawing pen, biro, felt tip, graphite stick or charcoal and chalk, also occasionally gouache or water colour.'

'I also draw and paint on found images from magazines and newspapers.' Anne generally uses small- and medium-sized spiral-bound, hard-backed books, containing the heaviest white paper available. Anne finds a major benefit of keeping a sketchbook is that it prevents her 'forgetting any ideas'.

As she spends much time in Cornwall, Anne has become fascinated with the landscape and looking at the margins between sea and land, and land and sky. Also, as her work has developed on the Doctoral Program she has connected her interest in mark-making with her concerns about global warming and the future of life on earth. The sketchbook landscapes use colour to draw attention to man's impact on, or damage to, the landscape through the use of colour. In her current printmaking work she has been using circular world images and is looking through sketchbook research for apposite backgrounds with which to surround her printed worlds. In the sketchbook landscapes depicted here, Anne was influenced by the watercolours of Georgia O'Keefe.

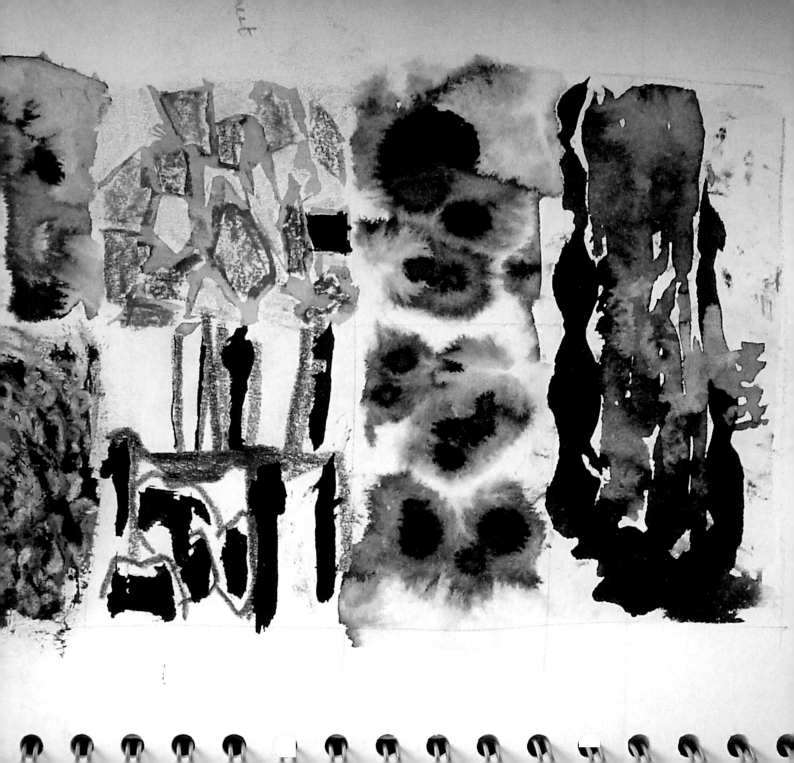

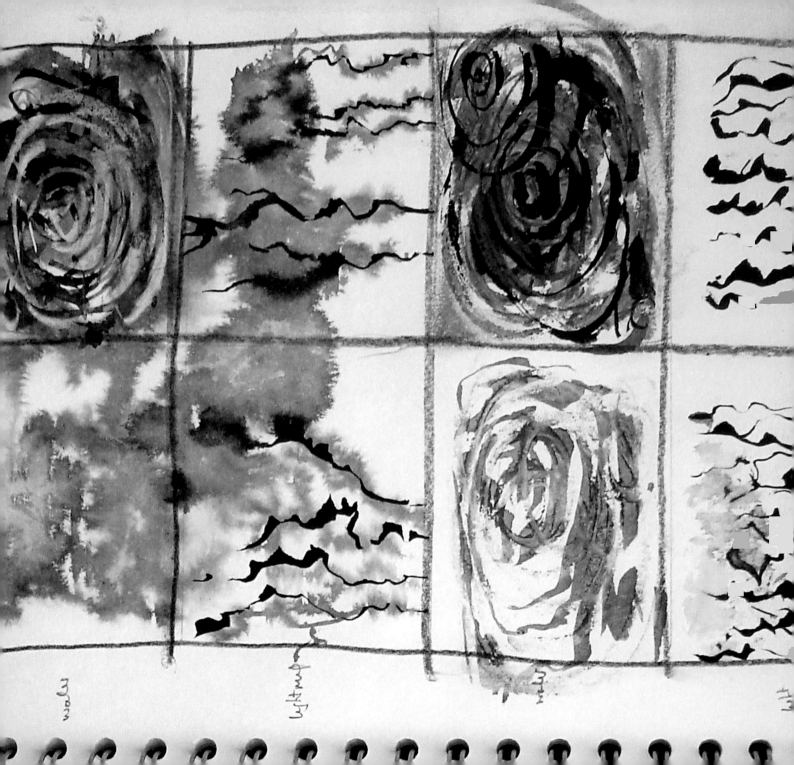

Sandy **Sykes**

PRINTMAKER, PAINTER AND MAKER OF ARTIST'S BOOKS,
Sandy Sykes works in sketchbooks of varying formats and sizes.

'I work in all of them for a long time, adding, taking away and altering any of the images as the fancy takes me. Picking them up at random, I also do a lot of writing in them and read them to remind myself of ideas I have not followed through. I particularly like the square format as the difficulty of the square makes more demands upon the imagery. I like slightly heavy, textured paper, off-white if possible. I have sometimes used old receipt books, lined ledgers and cheap little books with transparent paper found in jumble sales.'

I always take a small book (8 x 11 cm), lined or unlined, to exhibitions or on residencies and journeys, because I will be noting addresses, mapping routes, train times as well as sights and images. Larger books are used in the studio, sometimes to relax in at the end of a physically hard day making prints, or to make notes on how to start the work the next day – a good, sound method of getting started in the morning. I may be using up the materials or accumulated bits after a day's work as I hate waste, or I make drawings of what I'm working on in the studio in order to understand it. Some are taken to the house for various periods and in front of the television, often in current affairs programmes, I jot down shapes, events, spoken extracts.' ▷

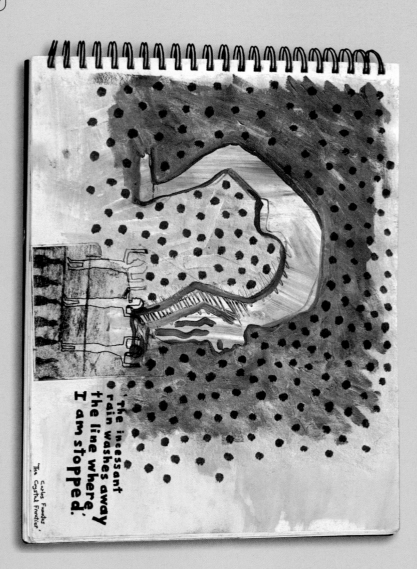

The incessant
rain washes away
the line where
I am stopped.

Carlos Fuentes
'The Crystal Frontier'

Sandy's sketchbooks contain newspaper cuttings, drawings from books, nature, memory, flights of fancy, and words and phrases of all kinds from many sources. She views them as a portable memory, a storage bin and a stimulating place to play.

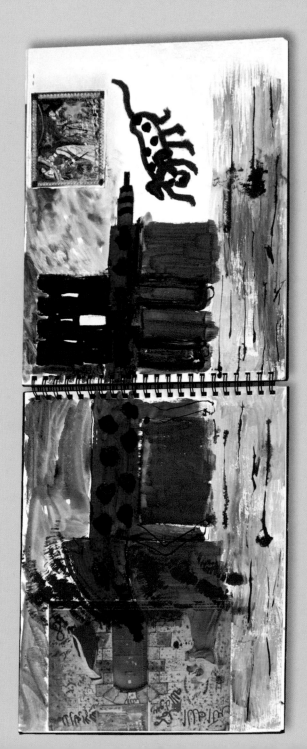

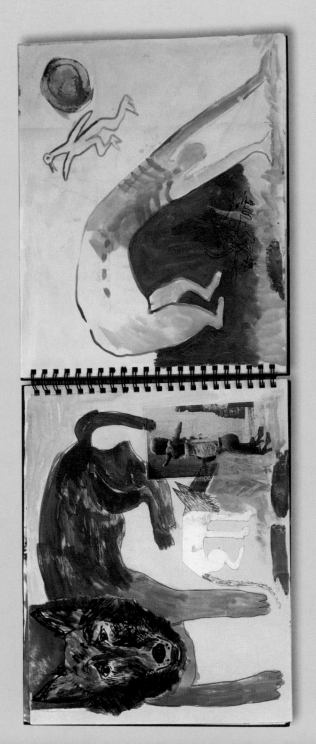

Sandy sometimes works in sketchbooks simply for the enjoyment and the sheer pleasure of making marks. 'I use them as a repository for photos, postcards, newspaper cuttings, drawings from books, museums, memory, flights of fancy and words and phrases of all kinds, which I often illustrate in the margins. I use a sketchbook to look at, a bit like a mirror and because there is absolutely no restraint, no rules, I often surprise myself later with the imagery that has emerged from my activity. It is also useful for the rushed, loose, uncaring drawings and remarks that I may discover six months later and decide to work into. By then I have moved on in my life and work and ideas have changed and developed into other directions. Bringing these newer ideas into the old drawings often leads to stronger or stranger or funnier amalgamations and insights.'

'As a child I could not keep either my hands or my brain still. All was excitement about the world. I had to put the thoughts down somewhere safe so that I was free to make and collect more astonishing experiences. My sketchbooks have always been for experimentation not prettiness. I use them as a place to play and as a portable memory which can be transported comfortably anywhere in the world.'

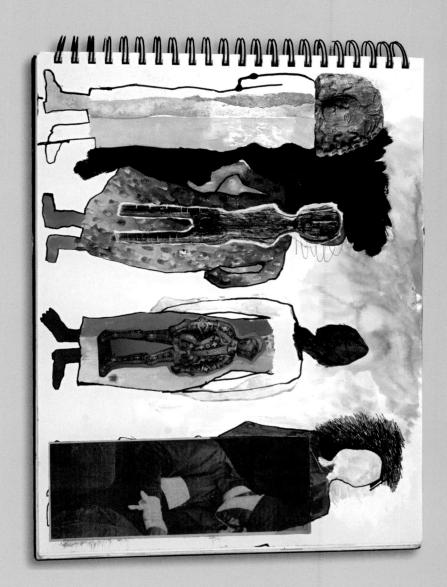

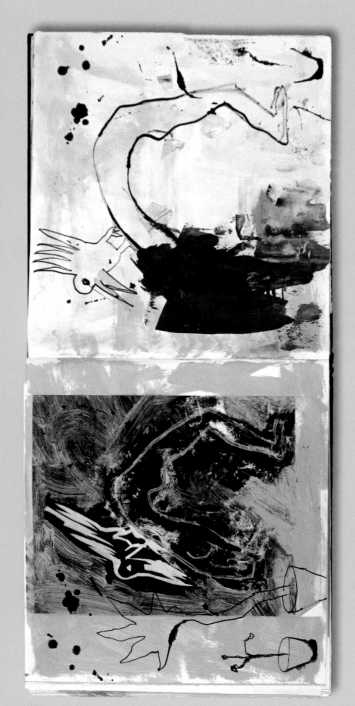

Jim Dunkley

SKETCHBOOKS PLAY A MAJOR PART IN THE WORK OF
artist Jim Dunkley. His art is diverse and includes painting, drawing, installation, video, performance and photography. His recent 'visual notebooks' contain drawings for their own sake or studies that explore ideas that might be developed on a larger scale or in a different medium. One such development has led to a series of large drawings of people in Jim's community in Hackney, East London.

The figures are three-quarters-life-size, drawn directly in pen-marker onto Polythene and they can be viewed individually or hung together to form groups, either wall-based or in an interior space, as installations. All of the research drawings for these started in one of Jim's sketchbooks.

Jim has kept sketchbooks since 1960, and has managed to hang onto one from that era. 'I use them for a variety of reasons but mainly for purposeful pleasure. Whatever the subject or reason, each page is a challenge and whatever the result, the next page offers another opportunity to experiment further with media and ideas.' Jim's books are various sizes, ranging from pocket-sized to very large and he works in a variety of ways, using mixed media at his studio, and pen or pencil for his pocket sketchbooks. They help him to think. 'I might be working objectively, imaginatively or a combination of both, but for me the "thinking" is never separate from the drawing process.'

One of Jim's sketchbook habits is the keeping of a small sketchbook solely for the purpose of drawing in jazz clubs, which he visits regularly. 'At jazz venues the combination of drawing, looking and listening allows me to be completely absorbed and switch off all other intrusive thoughts. I identify with the intense involvement of the musicians in their freely improvised playing

and try to capture something of this in my drawings of them. While the drawings are concerned with the moment and the sound, they are also portraits of individuals at work.'Some of his 'jazz books are incomplete as he sometimes rips out a page and gives it to the musician that he's drawn.

Jim has admired the sketchbooks of Picasso, Turner, Van Gogh and Constable, but regrets that it is often difficult to access contemporary artists' sketchbooks. His own books offer him the opportunity to experiment without concern about either failure or success. 'I've given many sketchbook drawings away, I've lost sketchbooks, it doesn't matter, I just do some more.'

'I certainly draw mainly for myself and cannot deny the pleasure in flicking through old sketchbooks and rediscovering half-forgotten drawings that carry their history in their making.'

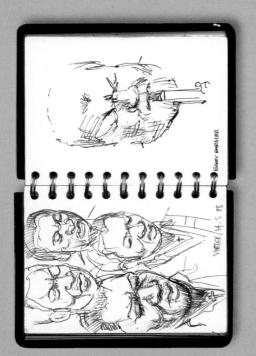

A selection from Jim's jazz sketchbooks in which he combines drawing, looking and listening while responding to live improvised music.

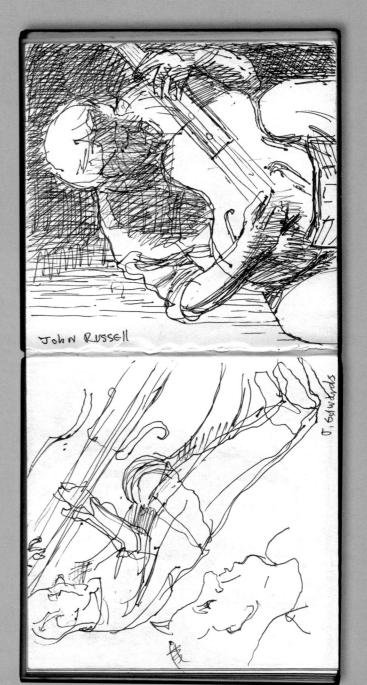

JOHN RUSSELL

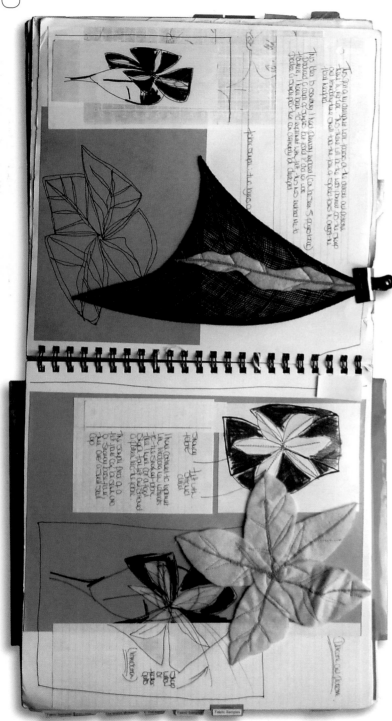

PROP MAKER AND MILLINER DANIELLE TAAFFE HAS A

Danielle Taaffe

different relationship to sketchbooks now that she is a practising designer: 'I often write and describe my ideas in a notebook, then I am able to visualise them from my descriptions. I sometimes draw a small sketch, but will then have lots of arrows coming from it, describing each element of my idea – materials, processes, inspirations, costs, etc.'

As a student, Danielle always worked on large sheets of paper and created her own sketchbooks, complete with a personalized front cover. These would contain a variety of paper types, ranging from ledger papers through to hand-made flower pressed pages and sometimes even a sheet of 6mm MDF. When she specialised in Millinery on a BA Honours Applied Arts course, she switched to a much smaller scale and as her work matured, she started to favour a square hardback sketchbook which she felt gave her ideas a more professional appearance. 'I would still add lots of different elements to the book. I needed the sketchbooks to be much smaller for these design ideas, because my drawings and research were somehow finer and more intimate.' If Danielle found herself without her sketchbook, she would (and still does) sketch on anything available, then add it to her book at a later date. 'I love these scrappy elements in a book; I think it shows the spontaneity of an idea.' ▷

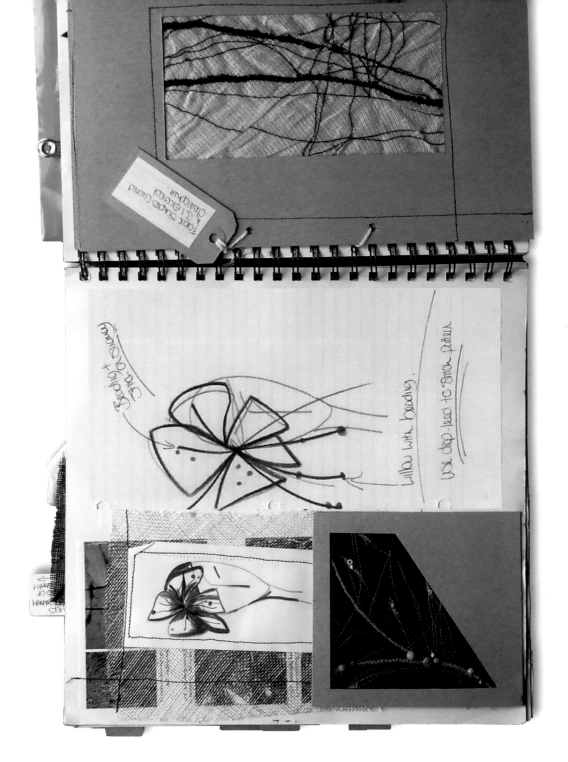

Danielle's sketchbooks are from her degree course where she explored pattern, shape and texture and developed the many skills that she now uses as a milliner and prop maker.

Her mixed-media approach makes for exciting sketchbooks. 'I love to draw with pens, pencils, paints and charcoal) – basically anything that will translate an idea. I would incorporate my techniques into the page, for example I would stitch a pattern for a hat directly onto a page, then annotate and analyse the outcome. I would approach each page differently, to create an interesting experience for the viewer.'

Now, as a freelance prop maker, Danielle works from other people's designs, so when it comes to producing these ideas in a 3D form, she experiments directly in 3D, creating small models or sample pieces, rather than working through visuals. 'On the

odd occasion I sketch something, it is usually on a scrap piece of paper or even a piece of MDF, to communicate my ideas to other people. The same can be said for my work as a milliner; when I am commissioned for a hat I may have to show the client an image of what I'm going to make, so that would require me to visualise it, but it can be thrown away once the hat or prop has been made.'

'I love looking back through my old sketchbooks created during my time at college and university. It makes me feel nostalgic, like looking back through old photographs; it reminds me of how much fun I had, and of all the hard work.'

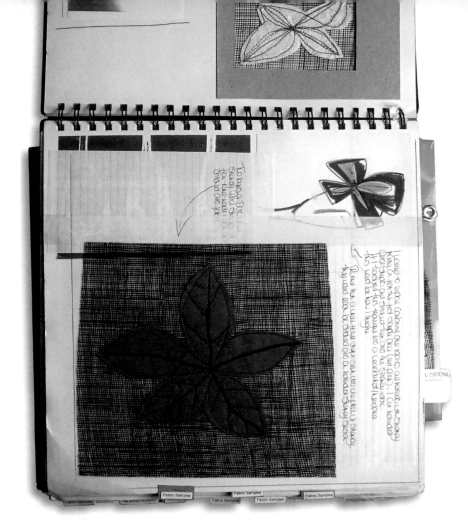

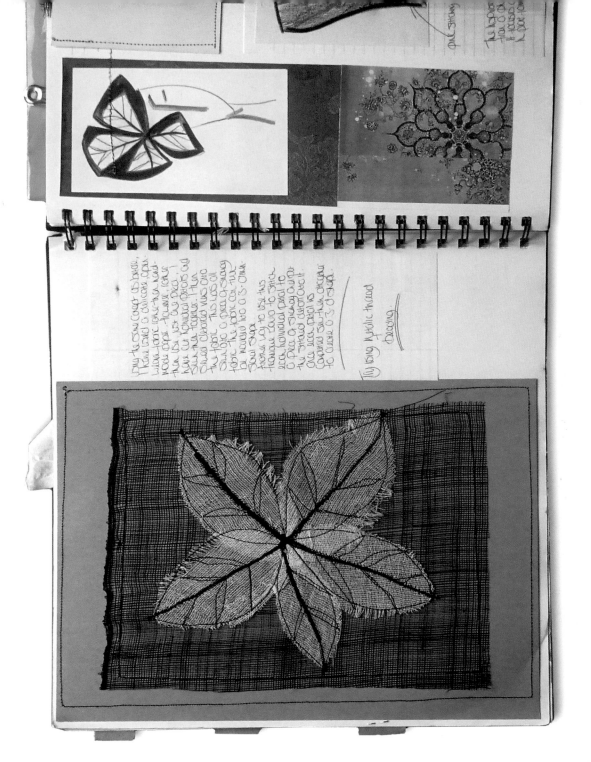

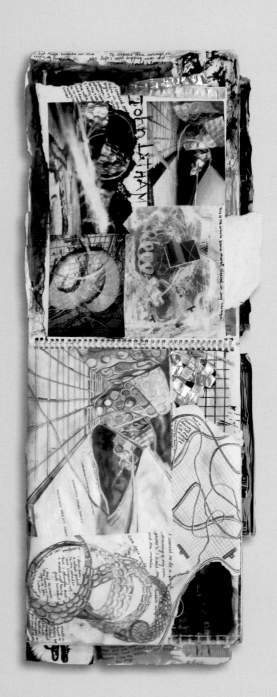

Emma **Lane**

to customise her sketchbooks, assembling them from different types of paper. 'I don't particularly like using white paper, but an off-white or brown paper is perfect for my work. I love using ring binders so that I can attach bits of work using thread or string, which create a more exciting book.' The covers in particular are another creative opportunity for Emma. She uses photographs and wire and sometimes sews into the images. 'Recently I made a clasp for one book, using fabric from an old scarf my Mum bought in South Africa, where we used to live.'

The set themes for Emma's examined work were 'stacked' and 'dystopia' (an imaginary place where everything is as bad as it can be). From these starting points, she has been encouraged to interpret and develop original concepts, through the creation of exciting sketchbooks that will lead on to final pieces of work. This coursework will be assessed at school, by her teachers and moderated by the exam board. Her interpretation of a dystopian world is based upon the idea of 'decay' and she has developed various metamorphoses depicting things rotting and rusting away, to convey a bleak and negative world.

'At the moment I am trying to find my feet and develop a certain style. I use my sketchbook to advance my skills, using various approaches with mixed-media. I like to work in a controlled way and although pieces may look experimental there is always an element or awareness of control. My favourite drawing materials are inks and biro and I like to sew into my drawings. I love making my work tactile so that the audience or viewer will want to touch it.' She is influenced by the work of artists Alberto Giacometti, 'messy, yet controlled; the sketchbooks of Henry Moore and also Francis Bacon.

Emma doesn't ever feel that her sketchbooks arrive at a conclusion. Her most recent one explores ideas inspired by Spanish art after a recent trip to Spain. 'I have concentrated a lot on the objects that I saw, and the idea of 'what is behind closed doors?' She is excited by the fact that you can never predict the direction or creative journey that a sketchbook will take you on: 'That is what is so wonderful about them!' Emma feels that her sketchbooks are her main creative output.

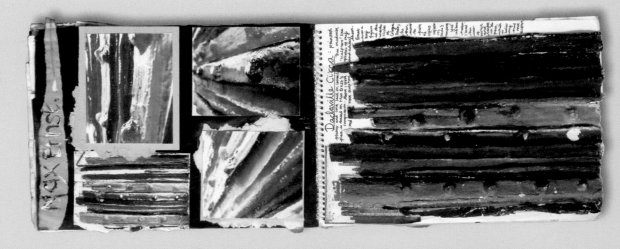

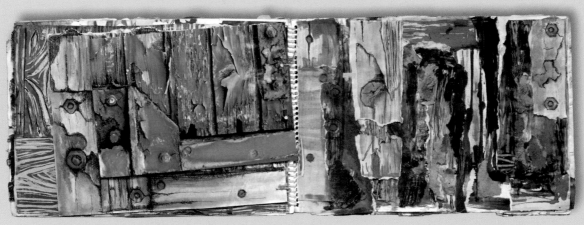

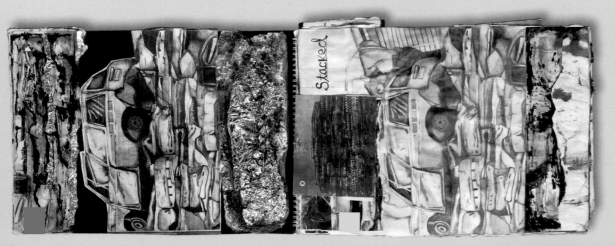

Emma's sketchbooks explore the themes of 'stacked' and 'dystopia' (an imaginary place where everything is as bad as it can be) using a great variety of media and approaches.

Website details for contributors

Richard Bell
www.wildyorkshire.co.uk/naturediary
Blog: www.wildyorkshire.co.uk

Liz Boast
www.parndonmill.co.uk
Go to: 'Who's here'

Abigail Brown
www.abigailbrown.co.uk

Corinna Button
www.corinnabutton.com

Christopher Corr
www.christophercorr.com

Anne Daniels
annedaniels.co.uk

Jim Dunkley
jimdunkley.wordpress.com

Madeline Fenton
www.madelinefenton.com

Sally Finning
sallyfinningillustration.blogspot.com

Mark Gamsu
mark.gamsu@openupsheffield.co.uk

Sheila Graber
www.graber-miller.com

Felicity House
www.felicityhouse.eu

Blair Hughes-Stanton
www.northhousegallery.co.uk/index.asp
Search: Blair Hughes-Stanton

William Kentridge
www.mariangoodman.com/artists/william-kentridge

David Meldrum
www.thefoodillustrator.com

Henry Moore
www.henry-moore.org

Jackie Newell
www.numasters.com/artists/view_artist.asp

Julia Rodrigues
moonjulia.blogspot.com

Jane Stobart
www.numasters.com/artists/view_artist.asp

Sandy Sykes
www.sandysykes.co.uk

Danielle Taaffe
www.danielletaaffe.com

Extraordinary Sketchbooks

Conclusion

There are a great many interesting and unusual sketchbooks on the market if you shop around. Small hardback books are perfect for slipping into your pocket. Concertina books are great for a vertical or horizontal subject. If you find white paper intimidating, see what is available in non-white paper such as a brown wrapping paper sketchbook or the pastel colours or Ingres paper – or black pages. Smooth paper will usually have a cut edge while some textured paper sketchbooks will have a deckled edge, indicating that the paper is hand-made. I recommend having several sketchbooks on the go and keeping each for a specific purpose.